COOL SHOPS
BARCELONA

teNeues

Editor: Aurora Cuito

Editorial assistant: Maia Francisco

Photography: Alejandro Bachrach

Introduction: Eva Raventós

Layout & Pre-press: Cris Tarradas Dulcet

Translations: Matthew Clarke (English), Susanne Engler (German),
Michel Ficerai/Lingo Sense (French), Maurizio Siliato (Italian)

Produced by Loft Publications
www.loftpublications.com

Published by teNeues Publishing Group

teNeues Publishing Company
16 West 22nd Street, New York, NY 10010, USA
Tel.: 001-212-627-9090, Fax: 001-212-627-9511

teNeues Book Division
Kaistraße 18, 40221 Düsseldorf, Germany
Tel.: 0049-(0)211-994597-0, Fax: 0049-(0)211-994597-40

teNeues Publishing UK Ltd.
P.O. Box 402, West Byfleet, KT14 7ZF, Great Britain
Tel.: 0044-1932-403509, Fax: 0044-1932-403514

teNeues France S.A.R.L.
4, rue de Valence, 75005 Paris, France
Tel.: 0033-1-55 76 62 05, Fax: 0033-1-55 76 64 19

teNeues Iberica S.L.
Pso. Juan de la Encina 2-48, Urb. Club de Campo
28700 S.S.R.R., Madrid, Spain
Tel./Fax: 0034-91-65 95 876

www.teneues.com

ISBN: 3-8327-9073-X

© 2005 teNeues Verlag GmbH + Co. KG, Kempen

Printed in Spain

Bibliographic information published by
Die Deutsche Bibliothek. Die Deutsche Bibliothek lists
this publication in the Deutsche Nationalbibliografie;
detailed bibliographic data is available in the Internet
at http://dnb.ddb.de.

Contents

Page

Introduction 5

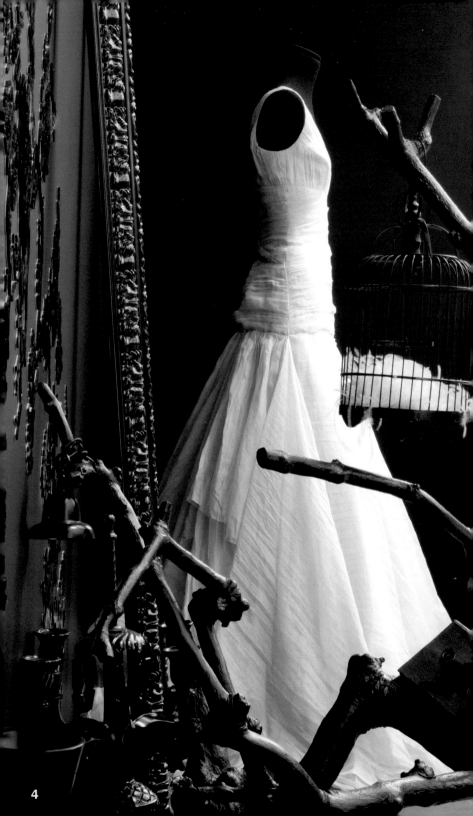

Introducción

Ventana al Mediterráneo y escaparate de nuevas tendencias, Barcelona se ha ido haciendo un hueco en los últimos años entre las ciudades europeas más innovadoras y culturalmente más activas; un lugar donde la historia y el diseño más contemporáneo se funden sin fisuras. La capital catalana es una ciudad siempre incompleta, en constante proceso de transformación, de búsqueda incesante de nuevos elementos con los que alimentar su eclecticismo, lo que la convierte en enclave de la posmodernidad.

Con un importante pasado comercial y más tarde industrial, a principios del siglo XX Barcelona se convirtió en capital de la vanguardia cultural; un núcleo urbano activo en el que proliferaron los medios de comunicación y donde se forjó una palpable inclinación hacia el consumo masivo. Más tarde, tras la transformación previa a los Juegos Olímpicos de 1992, la ciudad se mostró al mundo como un lugar absolutamente moderno, abierto y plural, muy receptivo a las tendencias procedentes del exterior, sobre todo culturales.

Esta personalidad inquieta se advierte de forma muy concreta en los campos del arte y el diseño, a los que se ha dado un gran impulso a través de innumerables iniciativas. La ciudad goza también de una amplísima oferta comercial que abarca todo tipo de artículos, estilos y procedencias. Este volumen recopila una muestra de la diversidad de tiendas y boutiques que se ha ido configurando –algunas de firmas reconocidas internacionalmente, como Custo, Camper o Miró, y otras inéditas– y también de otro tipo de espacios comerciales multifuncionales –como la tienda y galería de arte Iguapop–. Además de locales dedicados a la moda, complementos, mobiliario o lencería, hay también en esta publicación espacio para los libros, las joyas, los artículos de peluquería o los vinos; superficies que destacan por la exclusividad de los productos que ofrecen o por su llamativo diseño interior. Algunos de estos locales han sido diseñados por jóvenes interioristas barceloneses, o exhiben las creaciones de artistas de la ciudad, lo que supone otra forma de fomentar el diseño local. Todos estos singulares espacios comerciales, junto a otros locales emblemáticos, conforman la identidad de una ciudad que no reniega de la experimentación.

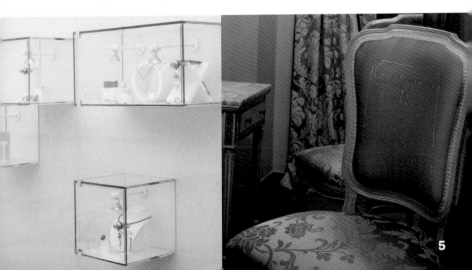

Introduction

As a window on the Mediterranean and a showcase for new trends, Barcelona has established itself within the last years as one of Europe's most innovative and culturally active cities, as a place where history and the latest contemporary design merge seamlessly. The Catalan capital is a city that is always incomplete, in a constant process of transformation, in an unending quest for new elements to nourish its eclecticism, making it a haven of post-modernity.

With its past as a major trading city and later as an industrial centre, Barcelona became a capital for the cultural avant-garde in the early 20th century, a buzzing urban hub with a thriving media presence and an evident predilection for mass consumption. Later, after the transformation triggered by the 1992 Olympic Games, the city presented itself to the world as totally modern, open and diversified, with a great receptivity to trends from outside, especially cultural contributions.

This restless nature is most specifically apparent in the fields of art and design, which have been strongly promoted through countless initiatives. The city also boasts an extremely wide range of shopping outlets, embracing all types of articles, styles and sources. This book offers a selection of the array of stores and boutiques that have emerged—some belonging to internationally recognized companies like Custo, Camper and Miró, and others that are newcomers on the scene—, as well as other types of multipurpose commercial spaces—like the Iguapop store and art gallery. Apart from premises devoted to fashion, complements, furniture and lingerie, this collection also finds room for books, jewelry, hairdressing articles and wine, on sale in settings that are noteworthy for the exclusive nature of their products or for a striking interior design that serves as an expression of their distinctive personality. Some of these stores have been brought to life by young interior designers from Barcelona, while others exhibit the work of artists from the city (another way of fostering local talent). All these unusual shopping spaces contribute, along with other emblematic settings, to the identity of a city that never shies away from experimentation.

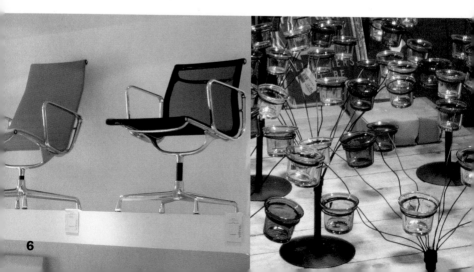

Einleitung

Barcelona, das Tor zum Mittelmeer und das Schaufenster für neue Trends, hat sich in den letzten Jahren unter den innovativsten und kulturell aktivsten Städten Europas seinen Platz erobert. Die katalanische Hauptstadt befindet sich in einem konstanten Umwandlungsprozess und man sucht unentwegt nach neuen Elementen, um den Eklektizismus der Stadt zu nähren.

Die Stadt nahm in der Vergangenheit im Handel eine sehr wichtige Stellung ein und ebenso fand eine starke industrielle Entwicklung statt. Zu Beginn des 20. Jh. wurde Barcelona zur Hauptstadt der kulturellen Avantgarde, in der sich die Kommunikationsmittel und Medien ausbreiten und in der ein deutlicher Hang zum Massenkonsum zu verzeichnen ist. Durch die Umgestaltung der Stadt für die Olympischen Spiele im Jahr 1992 zeigte man sich der Welt als modern, offen, vielfältig und mit einer großen Bereitschaft, kulturelle Trends aufzugreifen.

Dieses ständige, rastlose Suchen vor allem in den Bereichen Kunst und Design hat zu unzähligen Initiativen geführt. Auch das kommerzielle Angebot der Stadt ist sehr umfassend, es werden jede Art von Artikeln und Waren aus verschiedenen Ländern angeboten. In diesem Band zeigen wir Ihnen eine Auswahl der vielfältigen Shops und Boutiquen, die im Laufe der Zeit entstanden sind. Einige davon gehören zu renommierten, internationalen Marken wie Custo, Camper oder Miró. Auch interessante kommerzielle und multifunktionelle Räume wie z. B. der kombinierte Kunstgalerie-Shop von Iguapop werden vorgestellt. Außer Shops, in denen Mode, Accessoires, Möbel oder Unterwäsche verkauft werden, finden Sie in diesem Buch auch Geschäftsräume, die dem Buch, Schmuck, Friseurartikeln und dem Wein gewidmet sind. Die Verkaufsflächen bestechen durch die Exklusivität der feilgebotenen Produkte oder durch ihr attraktives Interior Design. Einige dieser Räumlichkeiten wurden von jungen Innenarchitekten aus Barcelona gestaltet, oder es werden Werke der Künstler der Stadt darin ausgestellt, eine andere Art und Weise, das Design in der Stadt Barcelona zu fördern. All diese einzigartigen kommerziellen Räume schaffen zusammen mit anderen auffallenden Gebäuden die Identität einer Stadt, die immer dazu bereit ist, mit Neuem zu experimentieren.

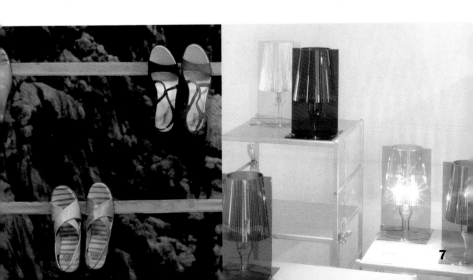

Introduction

Fenêtre sur la Méditerranée et vitrine des nouvelles tendances, Barcelone s'est fai une place ces dernières années parmi les villes européennes les plus innovantes e culturellement actives : un lieu où l'histoire et le design le plus contemporain fusion nent à l'unisson. La capitale catalane est une ville toujours incomplète, en proces sus constant de transformation, de recherche incessante de nouveaux élément avec lesquels alimenter son éclectisme, ce qui la convertit en enclave de la pos modernité.

Bénéficiant d'un important passé commercial et plus tard industriel, Barcelone s'es transformée au début du XXème siècle en capitale de l'avant-garde culturelle : u noyau urbain actif où purent proliférer les moyens de communication et se forger un inclinaison palpable envers la consommation de masse. Plus tard, suite à la mue pré cédant les jeux Olympiques de 1992, la cité s'est présentée au monde comme u lieu absolument moderne, ouvert et pluriel, très réceptif aux tendances provenant d l'extérieur, surtout culturels.

Cette personnalité inquiète s'affiche de forme très concrète dans les domaines d l'art et du design, qui ont reçu une forte impulsion grâce à des initiatives innombra bles. La ville jouit également d'une offre commercial très ample et couvrant tout typ d'article, de style et de provenance. Cet ouvrage collecte les exemples de la diversi té des boutiques et magasins qui s'est peu à peu formée – certaines de marque reconnues internationalement, comme Custo, Camper ou Miró, et d'autres inédites ainsi que d'autres types d'espaces commerciaux polyvalents – comme la boutique e galerie d'art Iguapop –. Outre les locaux dédiés à la mode, aux compléments, a mobilier ou à la lingerie, cette publication décline également les espaces consacré aux livres, aux bijoux, aux articles de coiffure et aux vins : des sites faisant la diffé rence de par l'exclusivité des produits proposés voire pour un design intérieur saisis sant, expression de la personnalité distinctive de la boutique. Quelques-uns de ce endroits ont été composés par de jeunes créateurs d'intérieur barcelonais ou expo sent les œuvres d'artistes de la ville : une autre façon d'encourager le design local Tous ces espaces commerciaux singuliers, outre d'autres sites emblématiques, for ment l'identité d'une cité qui ne se refuse pas à l'expérimentation.

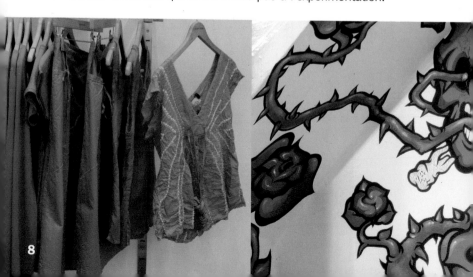

Introduzione

Finestra sul Mediterraneo e vetrina di nuove tendenze. Negli ultimi anni Barcellona si è ritagliata pian piano uno spazio tra le città europee più innovative e culturalmente più attive; un luogo dove la storia e il design più contemporaneo si fondono indissolubilmente. La capitale catalana è una città sempre incompiuta, in costante processo di trasformazione, di ricerca incessante di nuovi elementi con cui alimentare il suo eclettismo, aspetto che fa di essa una vera fucina di postmodernità.

Con un importante passato commerciale alle spalle e più tardi industriale, agli inizi del XX secolo Barcellona divenne capitale dell'avanguardia culturale; un nucleo urbano attivo dove proliferarono i mezzi di comunicazione e dove si forgiò una tendenza palpabile verso il consumo di massa. Più tardi, in seguito alla trasformazione subita prima delle Olimpiadi del 1992, la città si mostrò al mondo come un luogo assolutamente moderno, aperto e plurale, molto ricettivo nei confronti delle tendenze provenienti dall'esterno, soprattutto nel settore culturale.

Questa personalità inquieta si nota sensibilmente nel campo dell'arte e del design, promossi e sostenuti attraverso innumerevoli iniziative. La città vanta inoltre una vastissima offerta commerciale che comprende ogni tipo di articoli, stili e provenienze. Questo volume raccoglie alcuni esempi della grande varietà di negozi e boutique presenti a Barcellona – alcune delle griffe note internazionalmente come Custo, Camper o Miró, ed altre inedite – nonché di altri tipi di spazi commerciali multifunzionali – come il negozio e la galleria d'arte Iguapop –. Oltre a locali commerciali dedicati alla moda, agli accessori, ai mobili o alla biancheria intima, in questa pubblicazione c'è spazio pure per i libri, i gioielli, gli articoli per parrucchieri o i vini; superfici che si fanno notare per l'esclusività dei prodotti che offrono o per il loro vistoso arredamento interno, espressione del carattere distintivo del negozio. Alcuni di questi locali sono stati progettati da giovani interior designer barcellonesi o espongono le creazioni di artisti cittadini, un altro modo per promuovere il design locale. Tutti questi singolari spazi commerciali, assieme ad altri locali emblematici, formano l'identità di una città sempre pronta a sperimentare.

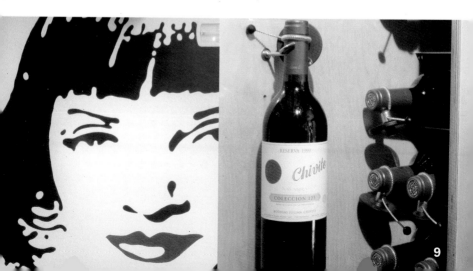

Agatha Ruiz de la Prada

Design: Veciana Design

Consell de Cent 314-316 | 08007 Barcelona
Phone: +34 934 871 667
www.agatharuizdelaprada.com
Subway: Passeig de Gràcia
Opening hours: Mon-Sat 10:30 am to 8:30 pm
Products: Women's, men's and kids' casual wear, home furnishings
Special features: Interior design concept matches the colorful patterns of the
acclaimed Spanish designer Agatha Ruiz de la Prada

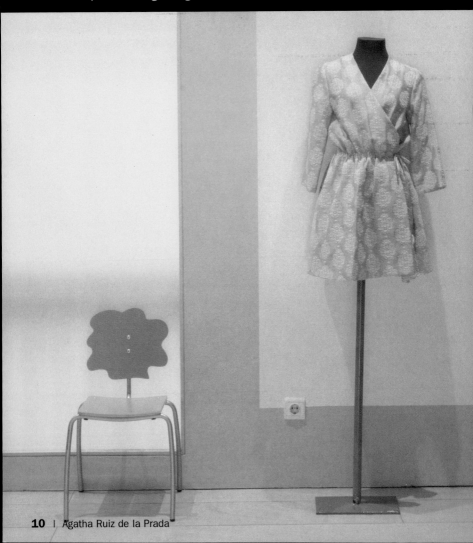

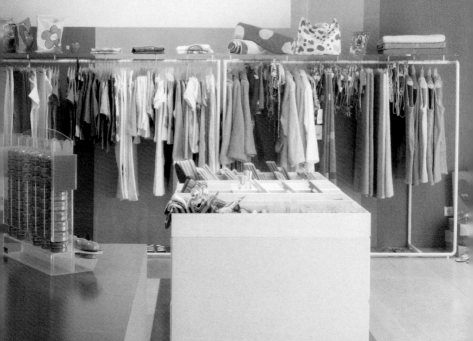

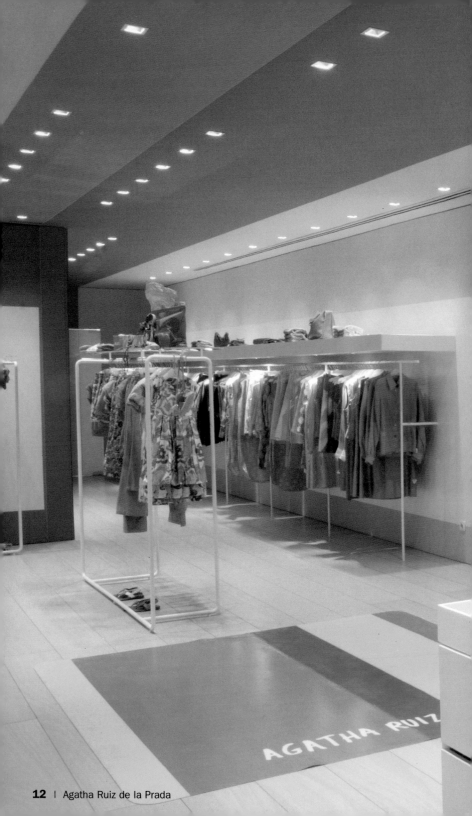

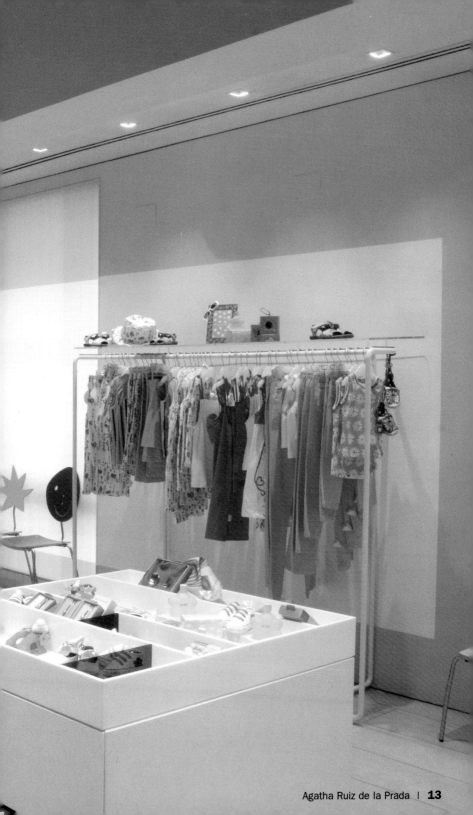

Anima

Design: Inés Rodriguez

Mestre Nicolau 12 | 08021 Barcelona
Phone: +34 932 405 666
www.animabcn.com
Subway: Muntaner
Opening hours: Mon 4:30 pm to 8 pm, Tue–Fri 10 am to 2 pm and 4:30 pm to 8:30 pm, Sat 10 am to 2 pm
Products: Contemporary jewelry
Special features: Clean and minimalist aesthetics, laboratory look

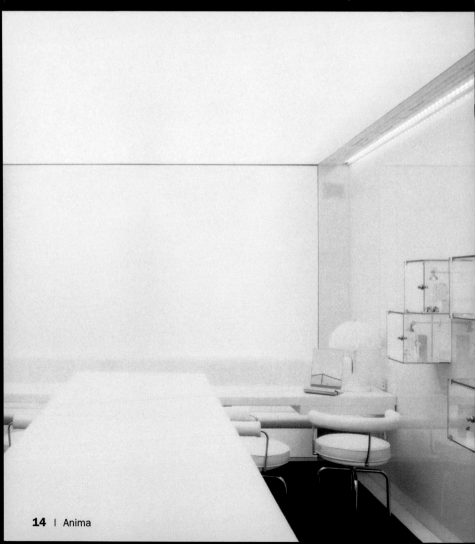

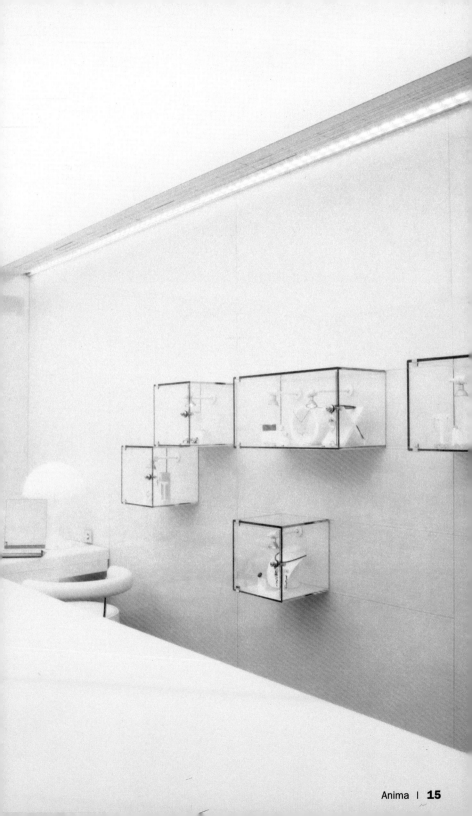

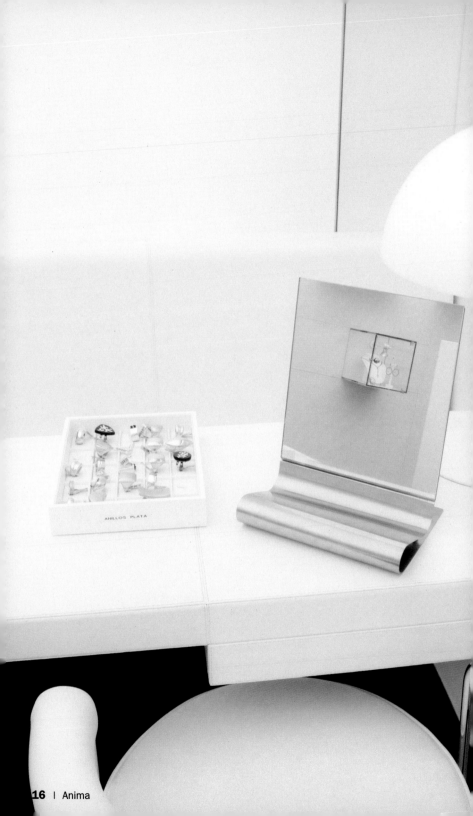

ANILLOS PLATA

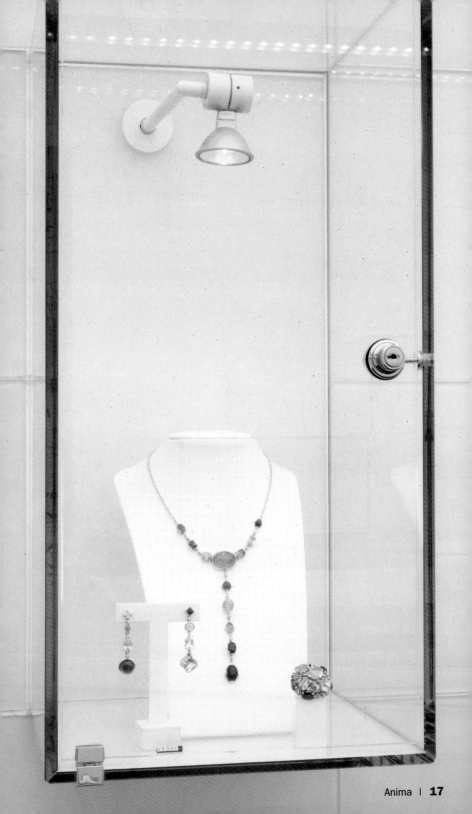

Arkitektura

Design: Conrado Carrasco, Carlos Tejada /
Estudio CCT Arquitectos, Marta Ventós

Via Augusta 185 I 08021 Barcelona
Phone: +34 933 624 720
www.arkitekturabcn.com
Subway: Muntaner
Opening hours: Mon–Fri 9:30 am to 2 pm and 4 pm to 7:30 pm, Sat 10 am to 2 pm
Products: Furniture, bathroom and kitchen fixtures, lighting
Special features: Furniture and objects designed by acclaimed architects and
designers, exhibitions and furniture presentations

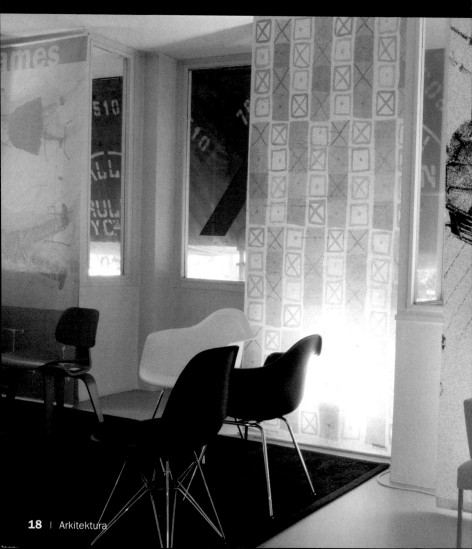

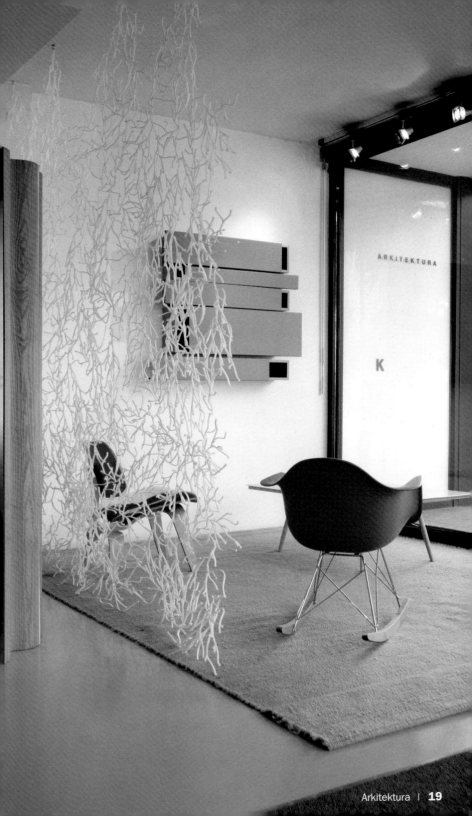

ARKITEKTURA

K

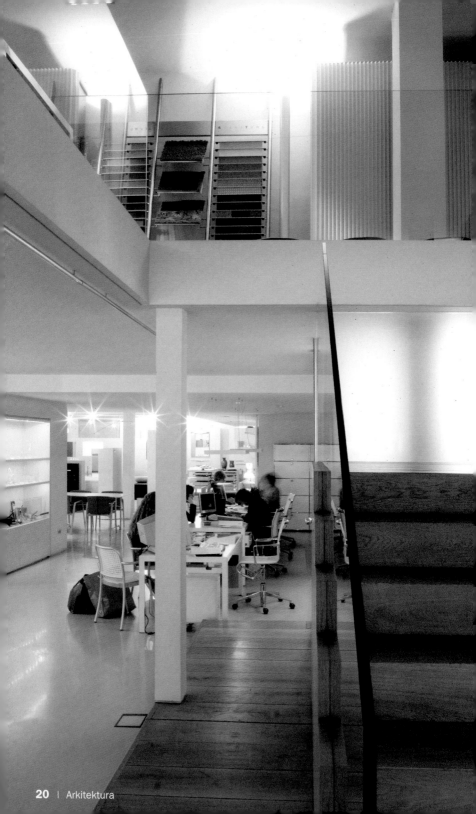

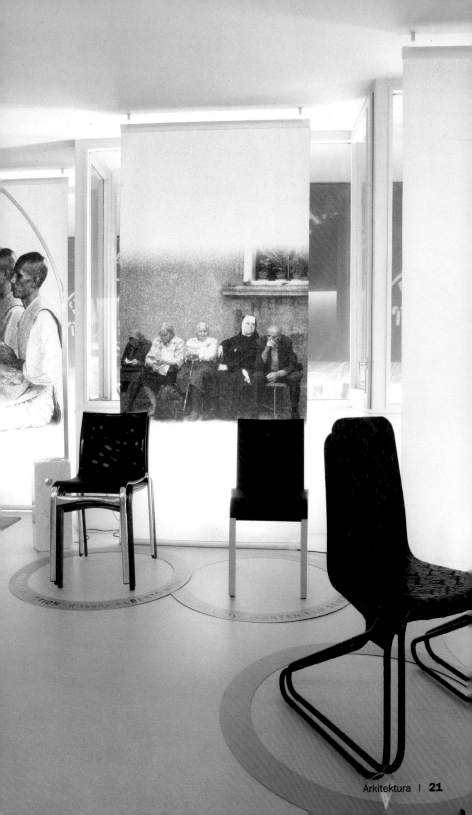

Arts and Claus

Design: Pepe Cortés

Muntaner 177 I 08036 Barcelona
Phone: +34 933 636 430
www.arts-claus.com
Subway: Hospital Clínic, Provença
Opening hours: Mon–Fri 10 am to 2 pm and 4 pm to 8 pm
Products: Paints
Special features: Custom made wide range of colors, color studies and projects

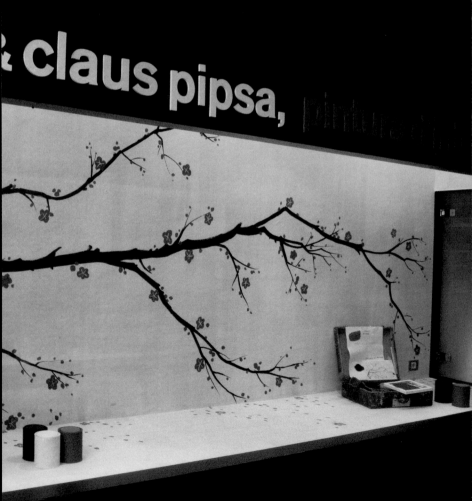

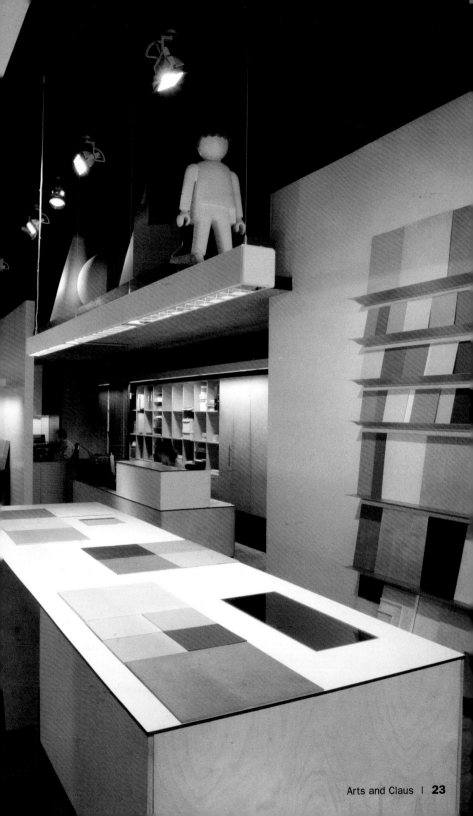

Av. Diagonal 460 | 08006 Barcelona
Phone: +34 933 222 694
www.bathtime.es
Subway: Diagonal
Opening hours: Mon–Sat 10:30 am to 2:30 pm and 4:30 pm to 8:30 pm
Products: Homewear, shoes, body care and bathroom accessories
Special features: Especially designed packaging

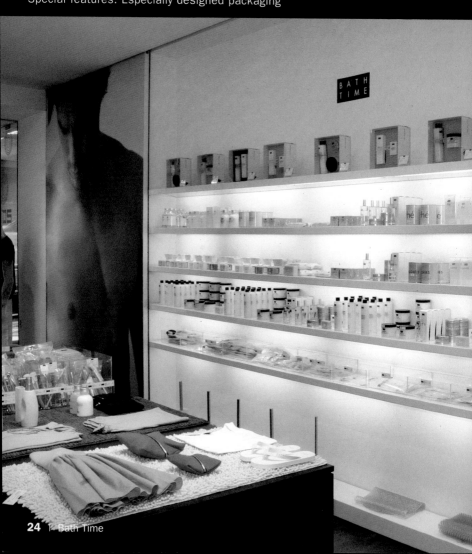

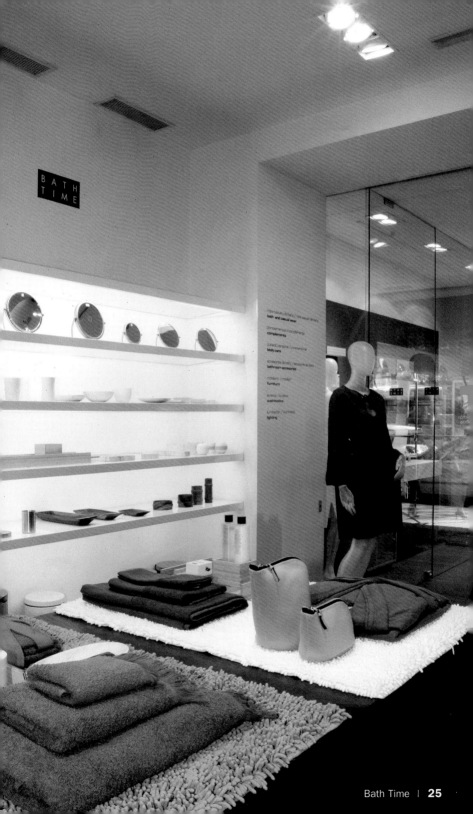

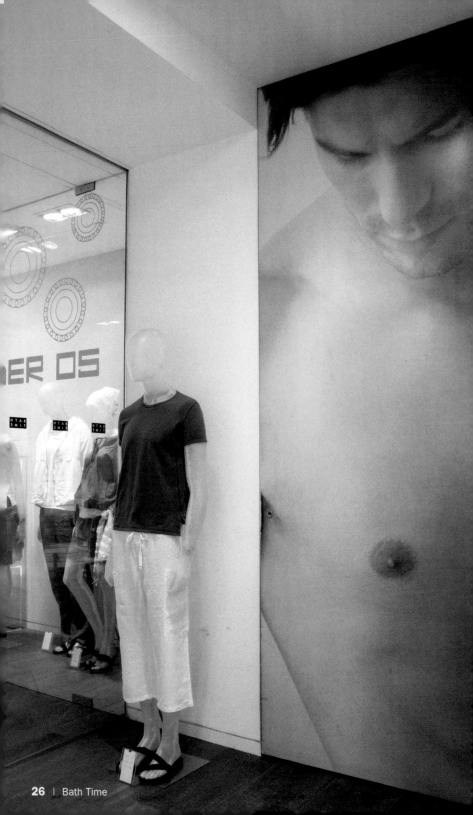

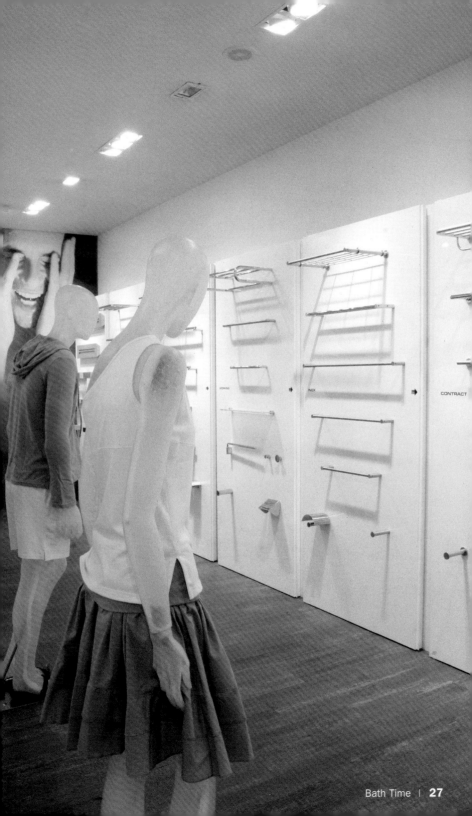

BD Ediciones de diseño

Design: Lluís Doménech i Muntaner, Cristian Cirici

Mallorca 291 | 08037 Barcelona
Phone: +34 934 586 909
www.bdediciones.com
Subway: Diagonal
Opening hours: Mon–Fri 10 am to 2 pm and 4 pm to 8 pm, Sat 10 am to 2 pm and
4:30 pm to 8 pm
Products: Furniture, lighting, kitchen and bathroom fixtures
Special features: Offers a wide range of selected designer objects and also
architecture and interior design projects

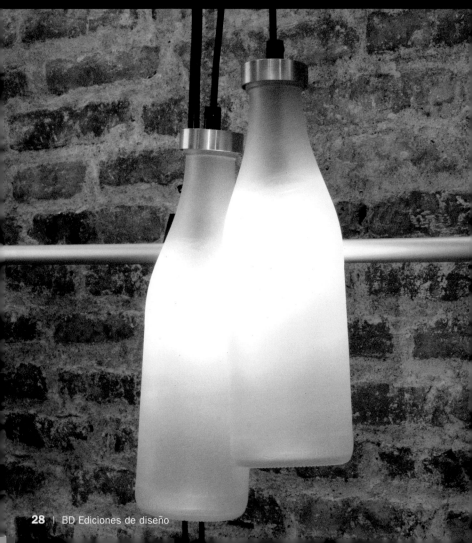

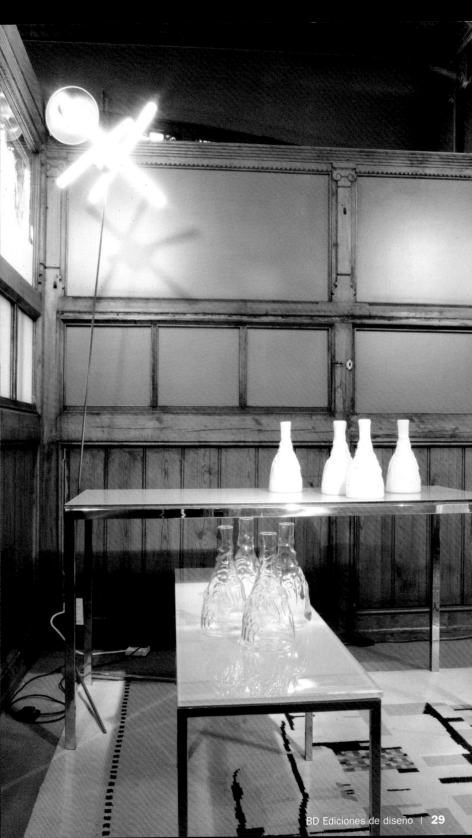

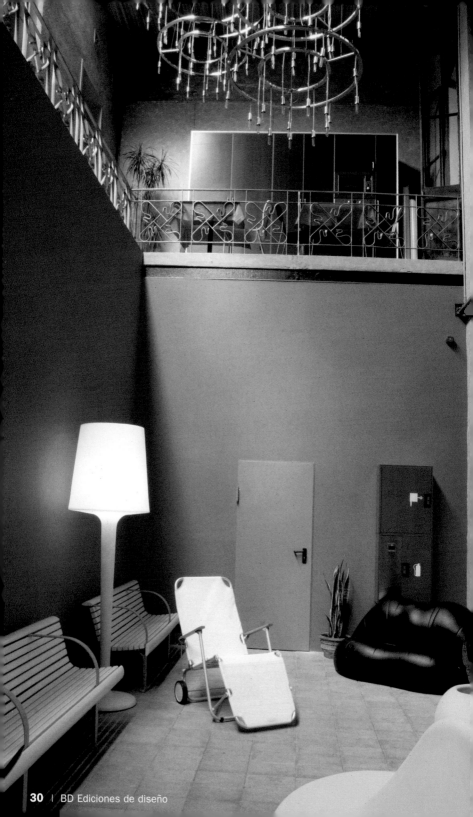

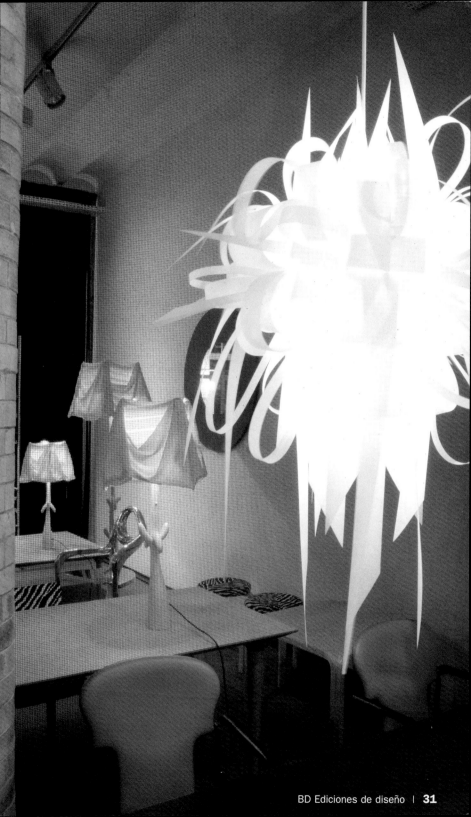

Biosca y Botey

Design: Ignasi Bonjoch & Associats

Av. Diagonal 557 | 08029 Barcelona
Phone +34 934 441 020
www.bioscabotey.com
Subway: Maria Cristina
Opening hours: Mon–Sat 10 am to 9:30 pm
Products: Wide range of lamps by selected designers and manufacturers
Special features: Decorative, professional, industrial and exterior lighting

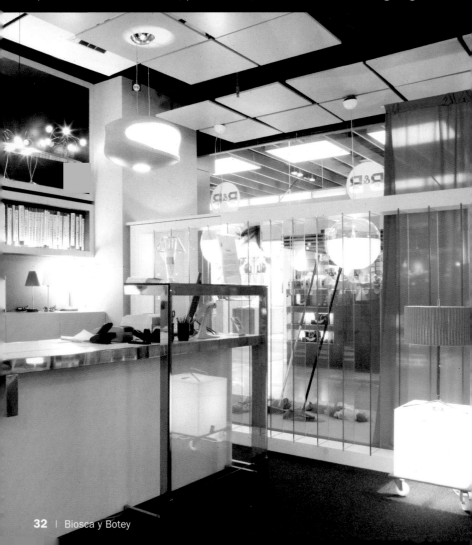

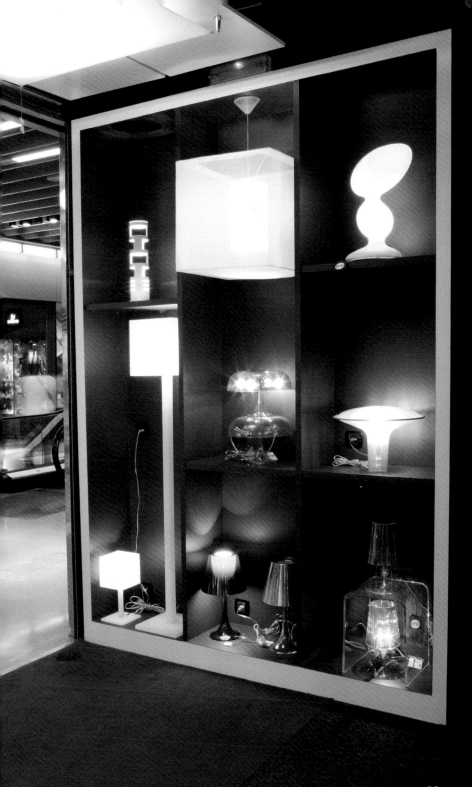

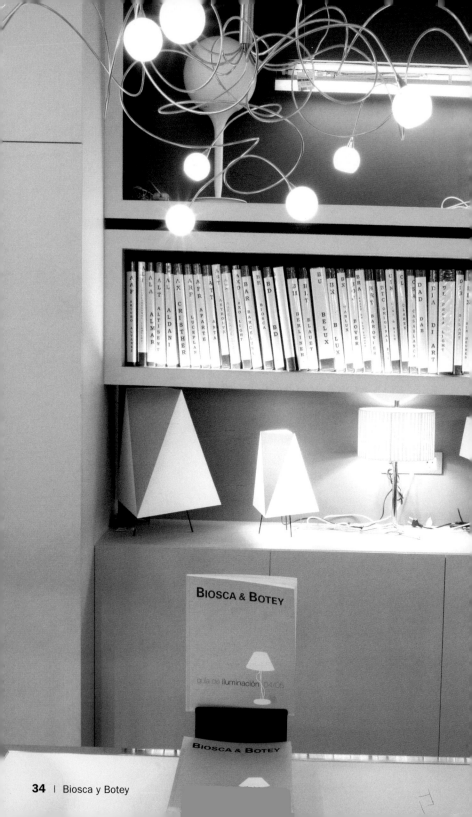

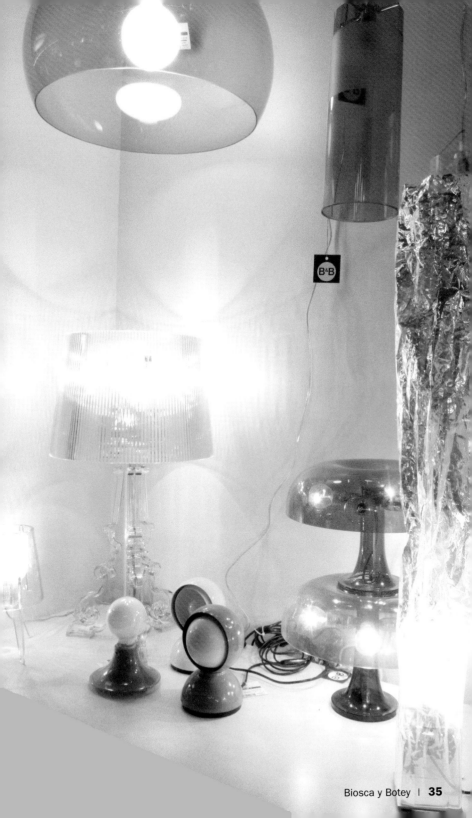

Pelai 13-37 | 08001 Barcelona
Phone: +34 933 024 124
www.camper.com
Subway: Catalunya
Opening hours: Mon–Sat 10 am to 10 pm
Products: Camper shoes, men's and women's collections
Special features: Design matches company's philosophy

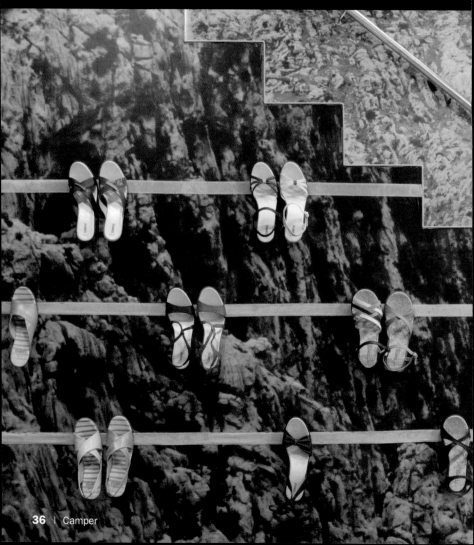

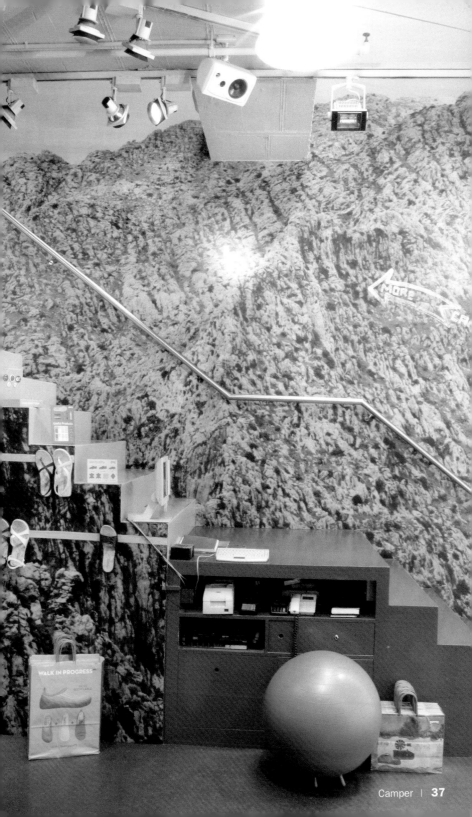

WALK IN PROGRESS

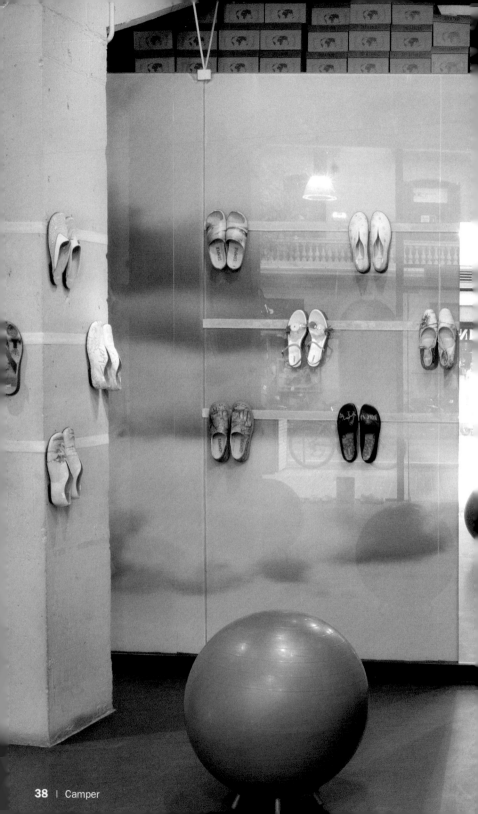

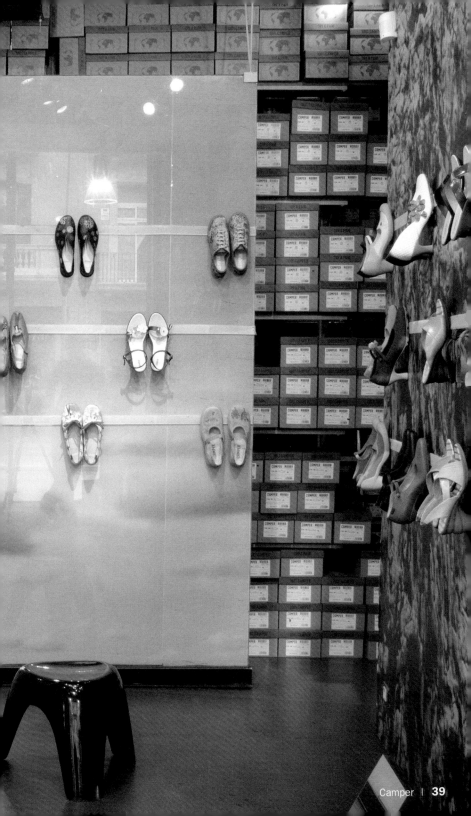

Central del Raval

Design: Enric Granell

Elisabets 6 | 08001 Barcelona
Phone: +34 933 170 293
www.lacentral.com
Subway: Catalunya
Opening hours: Mon–Fri 10 am to 9:30 pm and Sat 10 am to 9 pm
Products: Books, music, magazines
Special features: Includes a nice cafeteria with patio

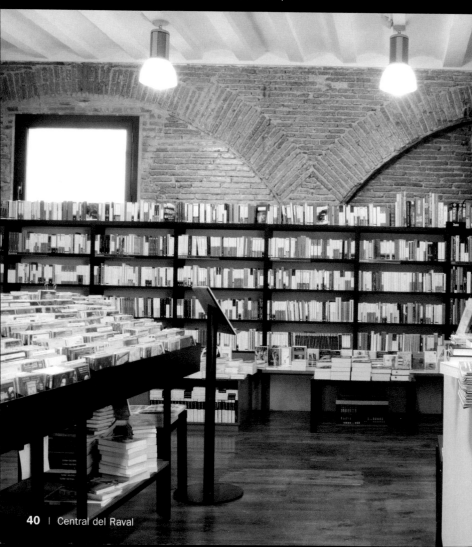

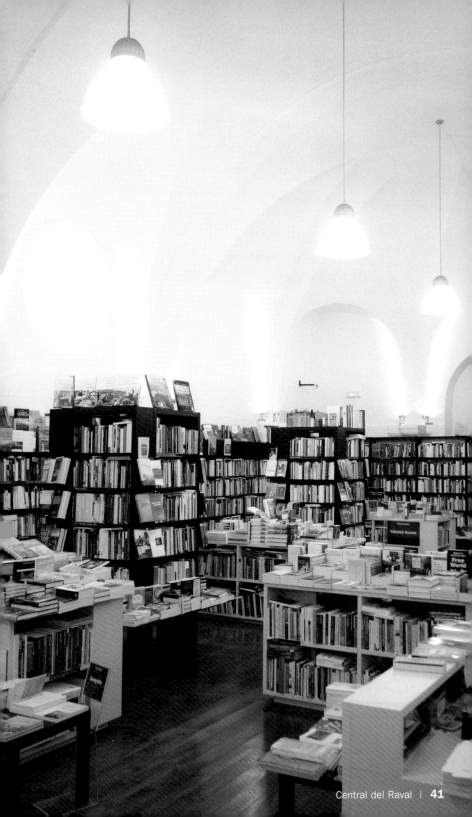

Clear

Design: Yaya Tour, Coloco

Pi 11 I 08002 Barcelona
Phone: +34 933 170 822
www.clearbcn.com
Subway: Liceu, Catalunya
Opening hours: Mon–Fri 10 am to 9 pm and Sat 11 am to 8 pm
Products: Hairdresser and beauty care
Special features: Clean and white lines to create a minimalistic but
sophisticated ambience

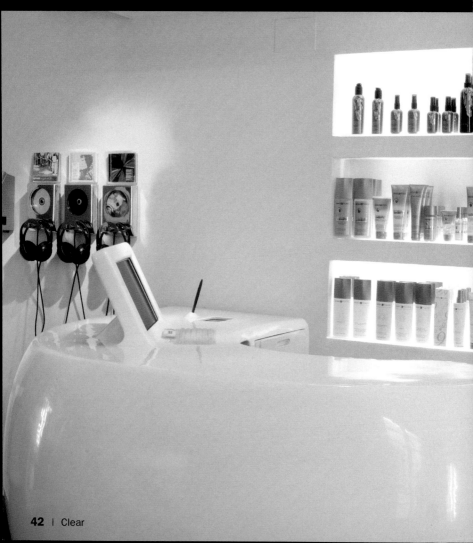

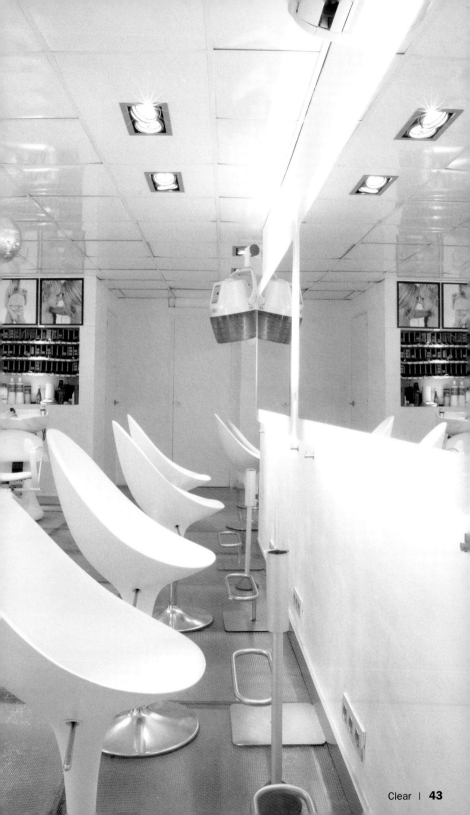

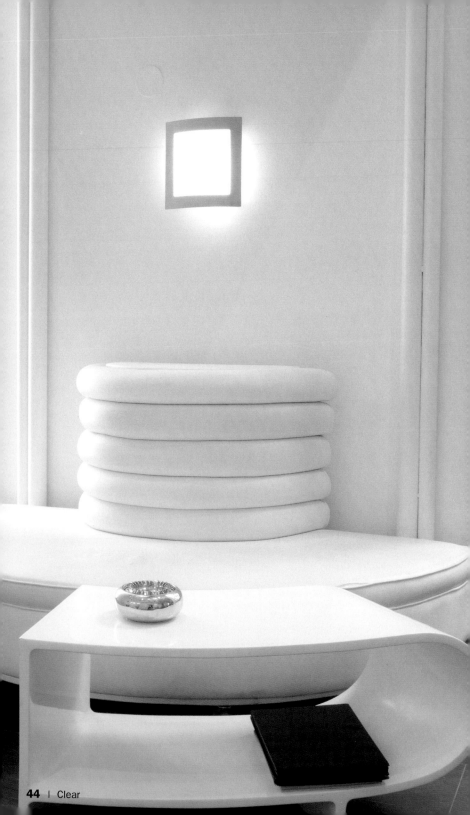

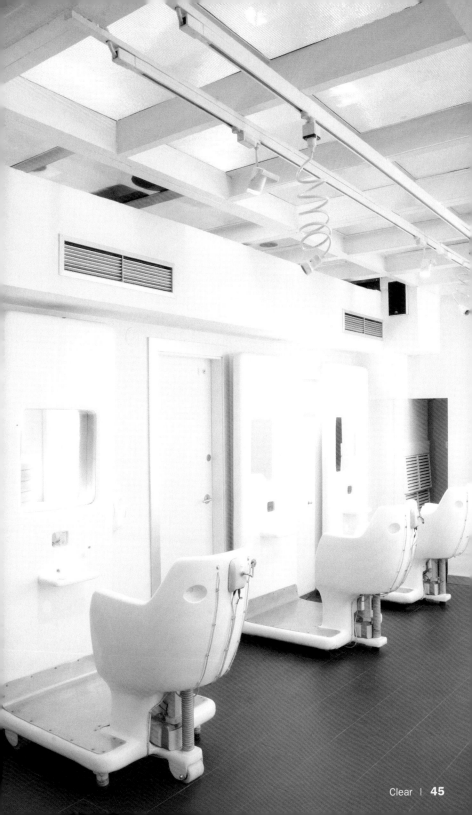

Comerç 29 | 08003 Barcelona
Phone: +34 932 688 437
Subway: Barceloneta, Arc de Triomf
Opening hours: Tue–Sat 1 pm to 9 pm
Products: Limited edition shoes, exclusive streetwear clothing, vinyl toys
Special features: Modern interior design, graffiti paintings on some walls

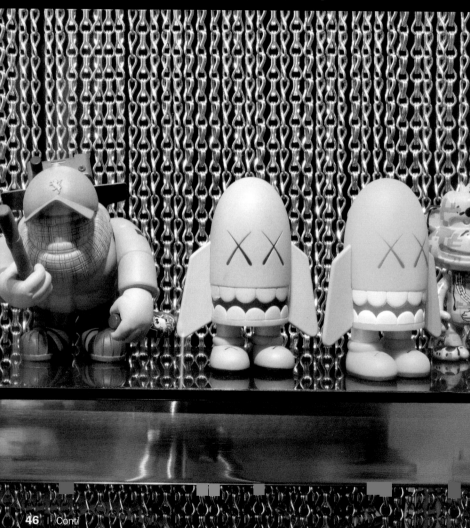

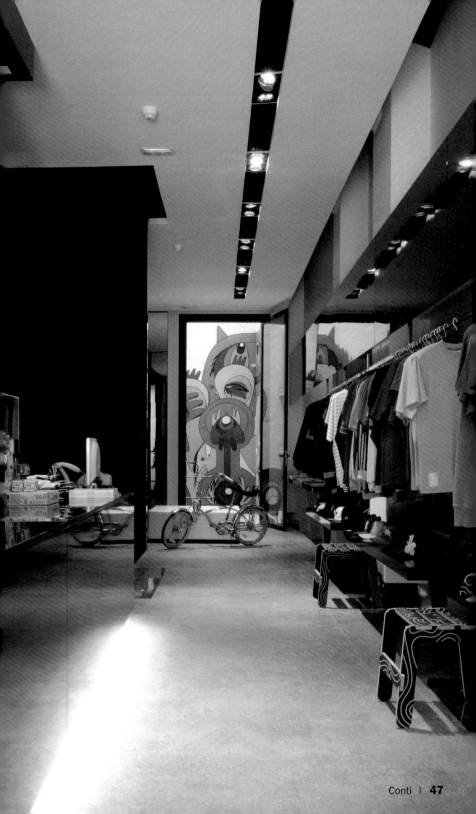

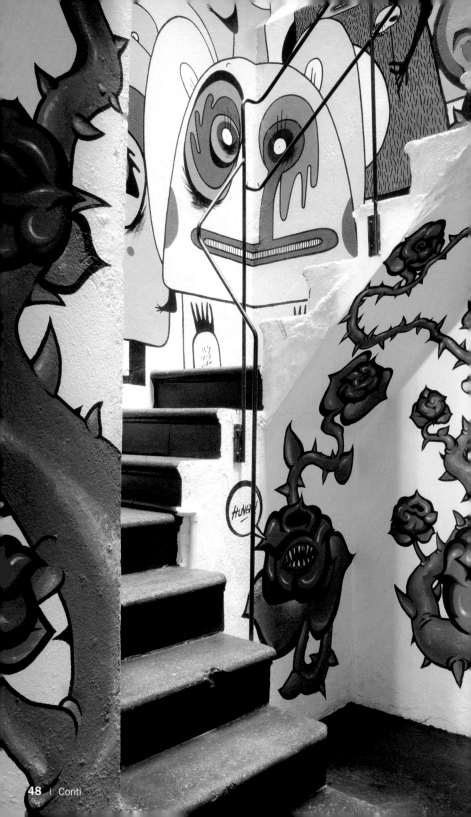

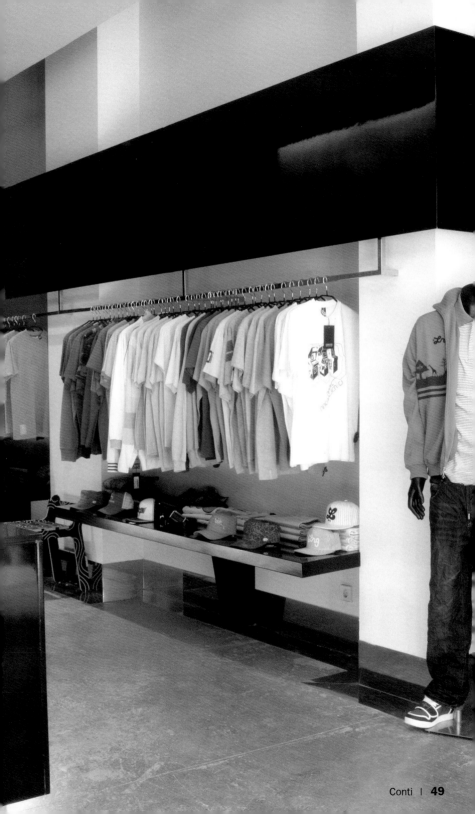

Corium

Design: Sandra Tarruella, Isabel López

Passeig de Gràcia 106 | 08008 Barcelona
Phone: +34 932 175 575
www.coriumcasa.com
Subway: Diagonal
Opening hours: Mon–Sat 10 am to 8:30 pm
Products: Men's and women's accessories, gift objects
Special features: Sophisticated and luxurious finishes

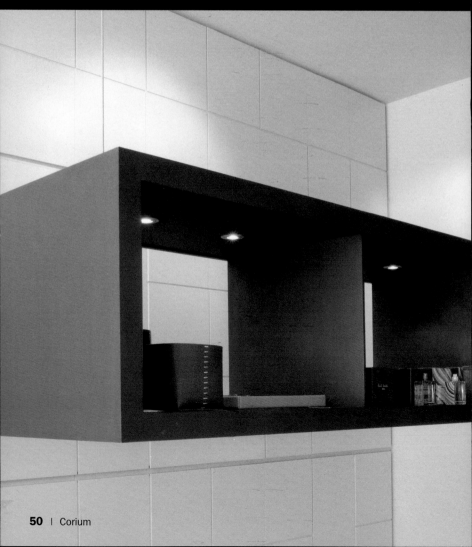

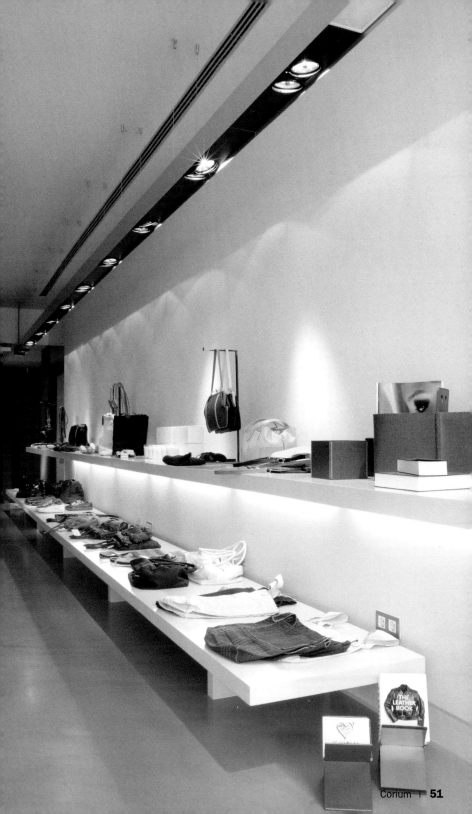

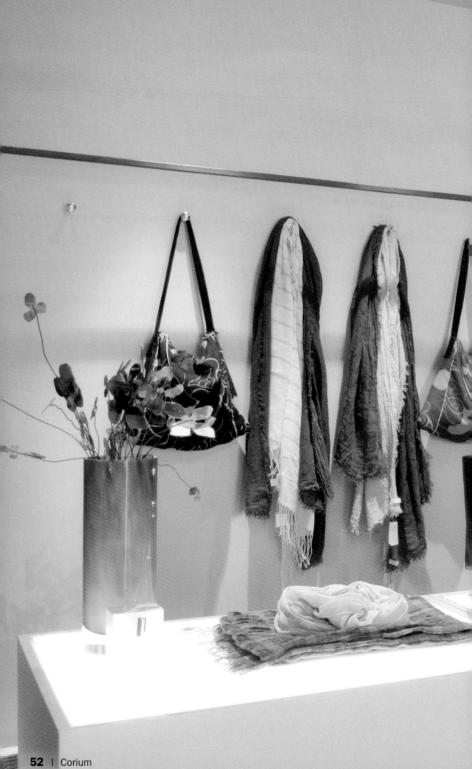

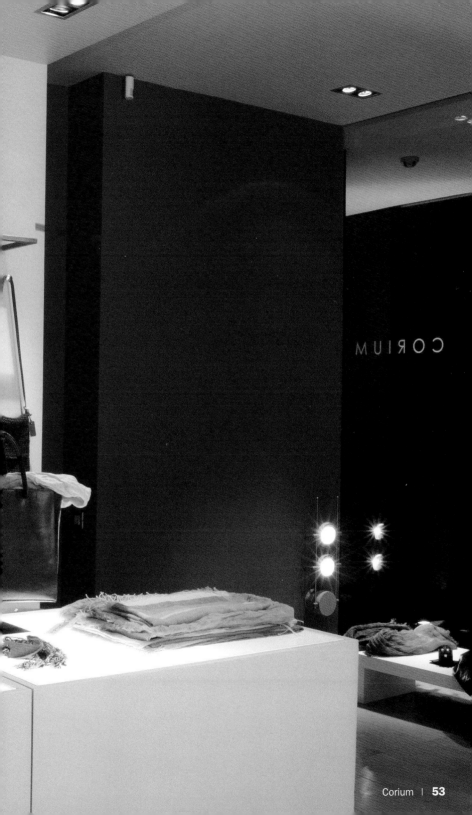

Custo Barcelona

Design: Custo Barcelona team

Av. Diagonal 557 | 08029 Barcelona
Phone: +34 933 222 662
www.custo-barcelona.com
Subway: Maria Cristina
Opening hours: Mon–Sat 10 am to 9:30 pm
Products: Men's and women's collections, accessories, swimwear
Special features: Specially designed lighting to emphasize textile textures and patter

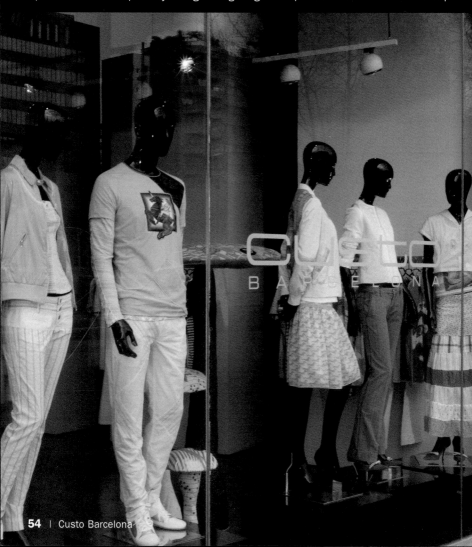

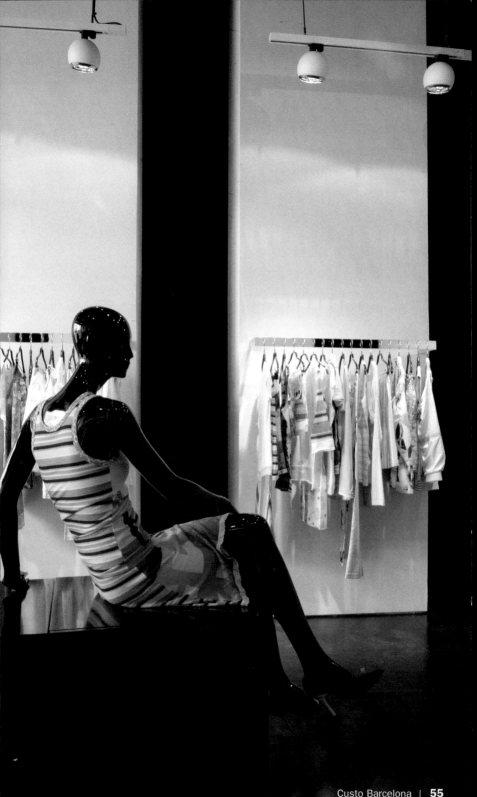

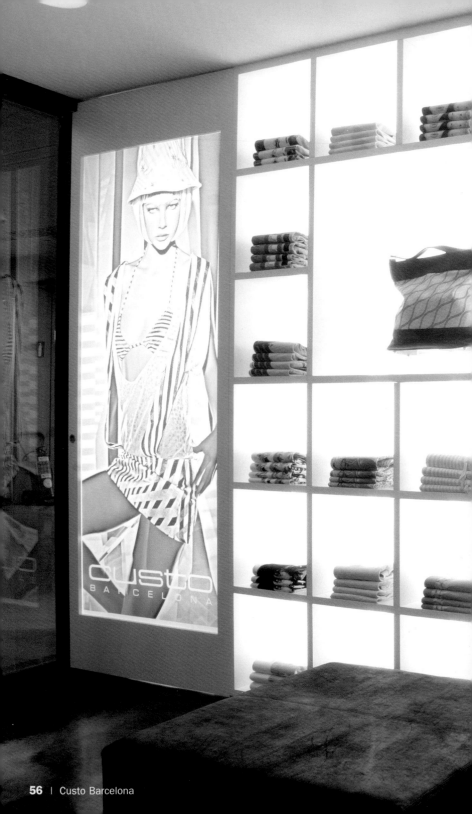

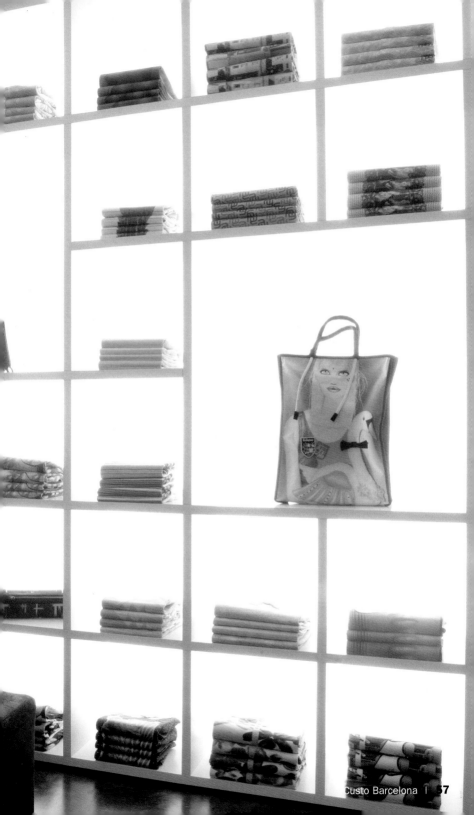

Dotze de Cors

Design: Ignasi Bonjoch

Av. Diagonal 557 | 08029 Barcelona
Phone: +34 934 053 559
Subway: Maria Cristina
Opening hours: Mon–Sat 10 am to 9:30 pm
Products: Intime home wear, swimwear, lingerie
Special features: Selected lingerie designers

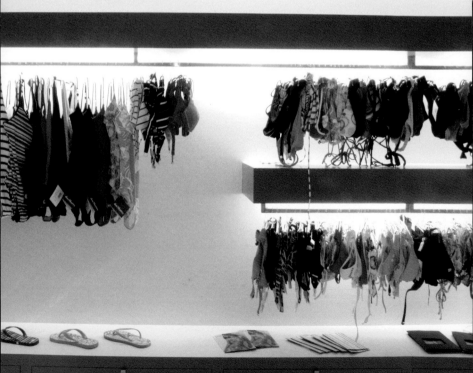

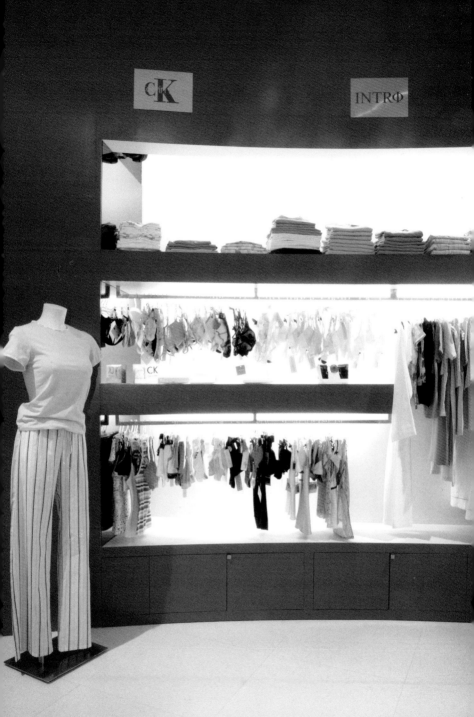

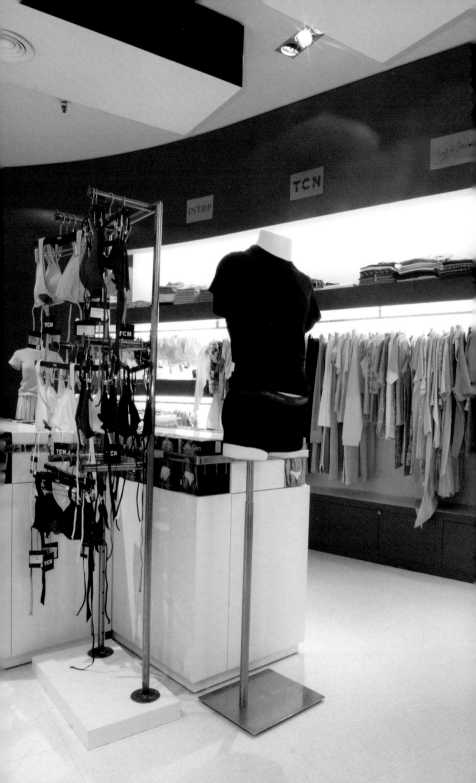

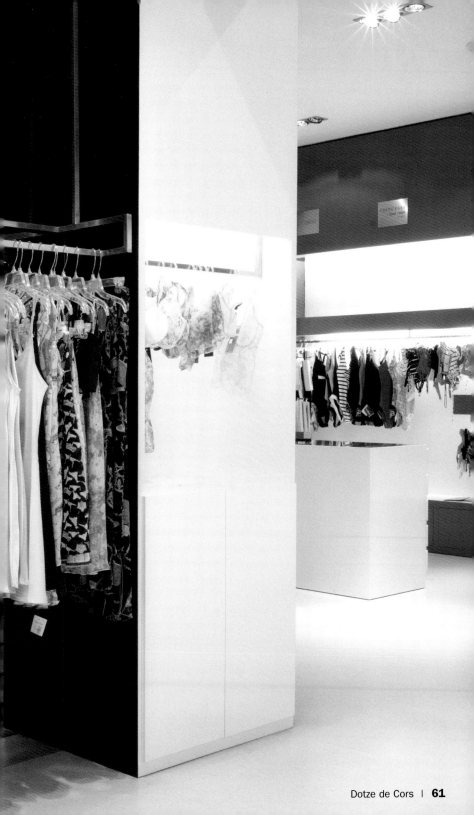

Gonzalo Comella

Design: GCA, Joan Pere

Passeig de Gràcia 6 | 08007 Barcelona
Phone: +34 934 126 600
www.gonzalocomella.com
Subway: Catalunya
Opening hours: Mon–Sat 10 am to 9 pm
Products: Men's, women's and kids' collections
Special features: Selected international fashion designers

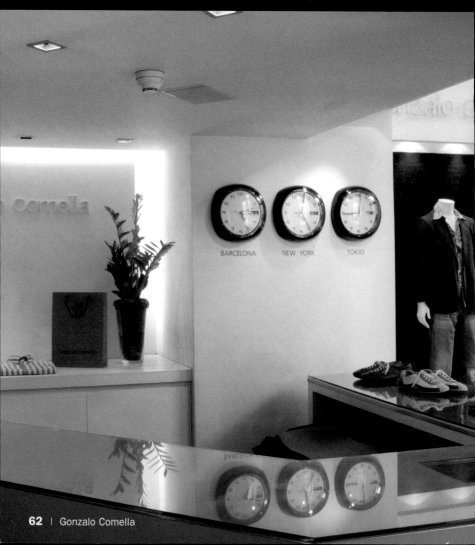

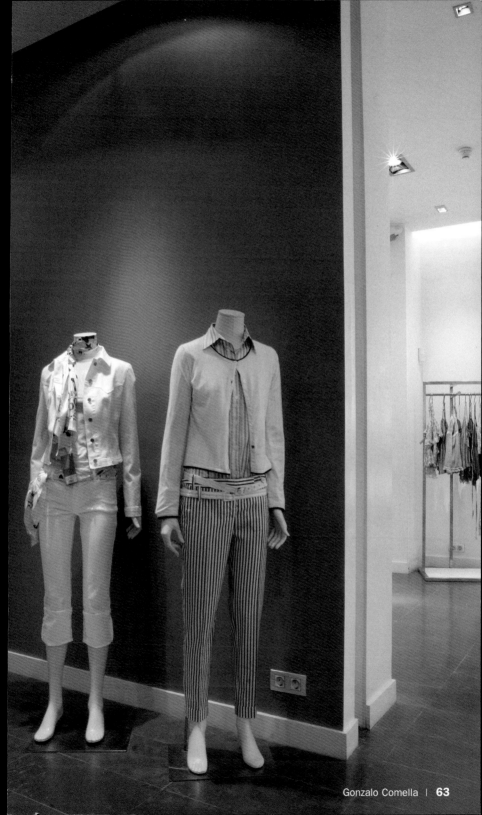

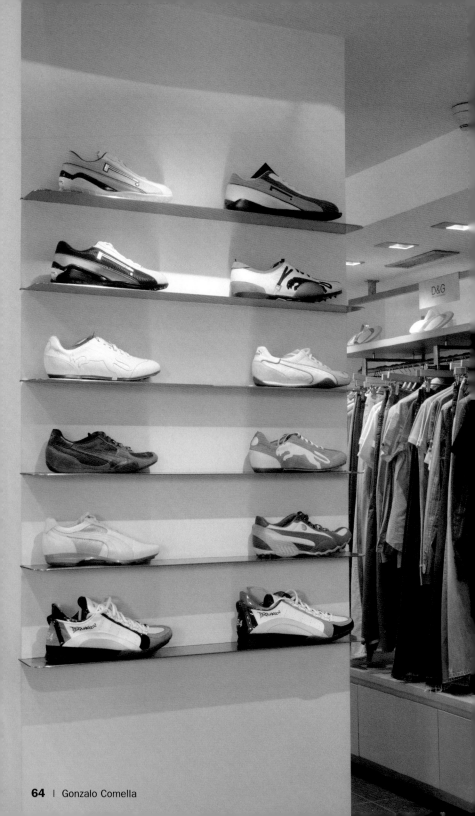

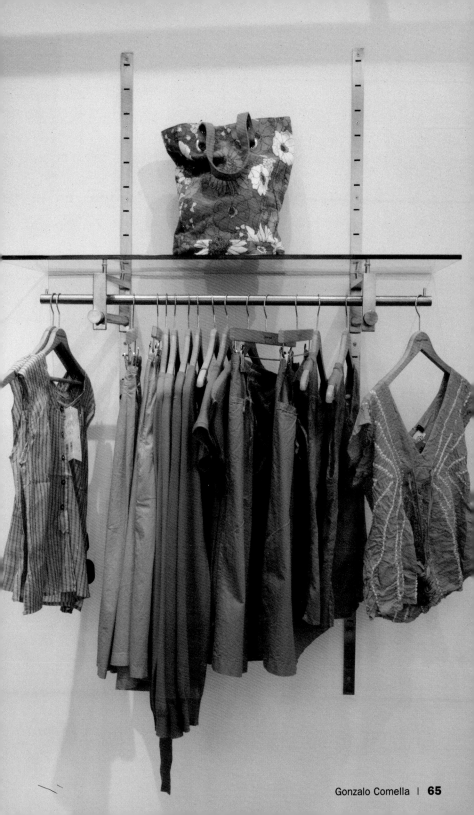

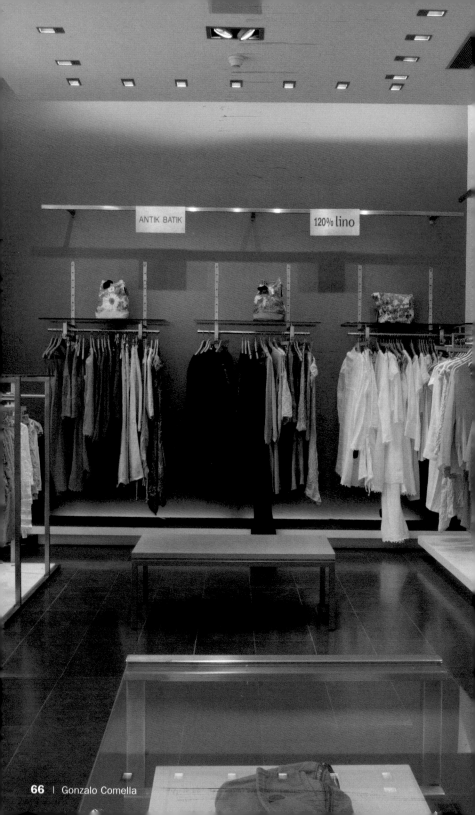

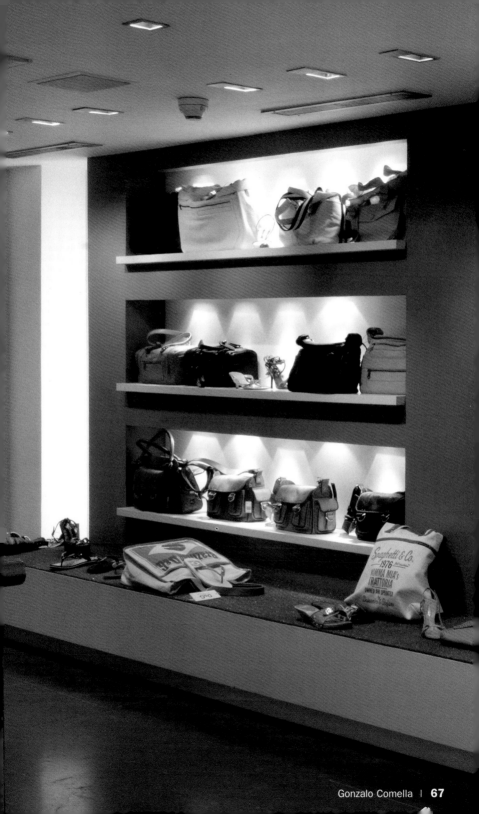

Phone: +34 934 189 550
www.greekbcn.com
Subway: Muntaner
Opening hours: Mon–Fri 9:30 am to 1:30 pm and 4:30 pm to 8:30 pm, Sat 10 am to 2
Products: Furniture, office, bathroom and kitchen fixtures
Special features: Selected furniture designers and manufacturers, also offers
architecture and interior design projects

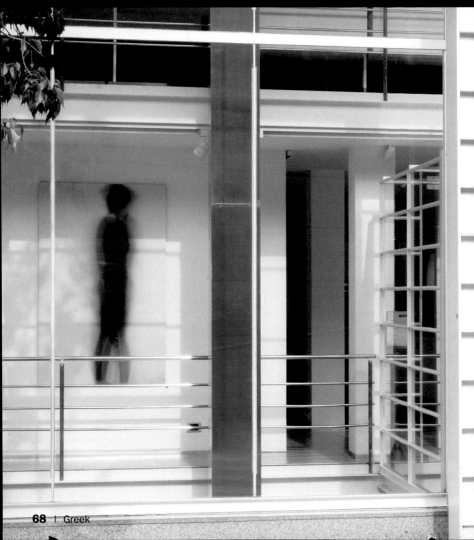

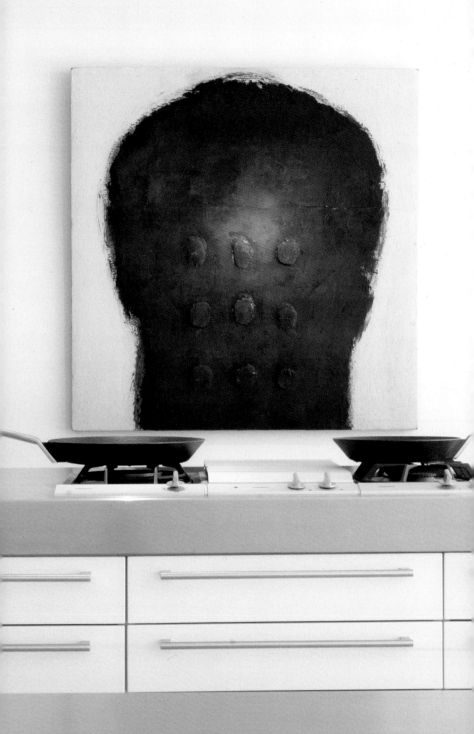

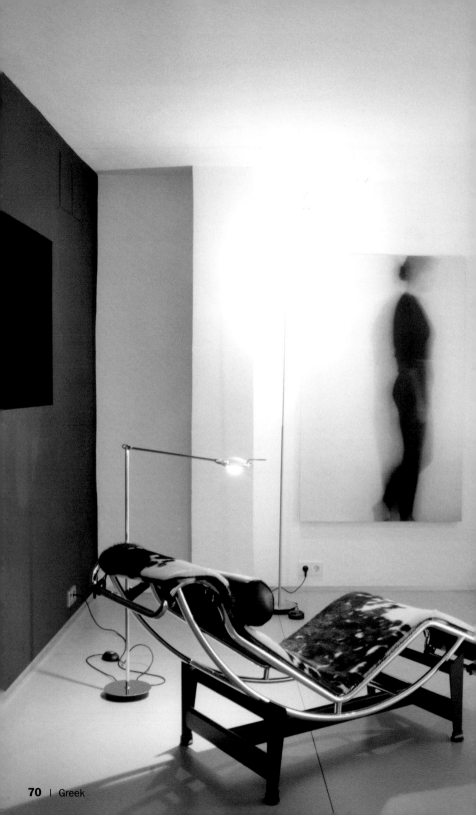

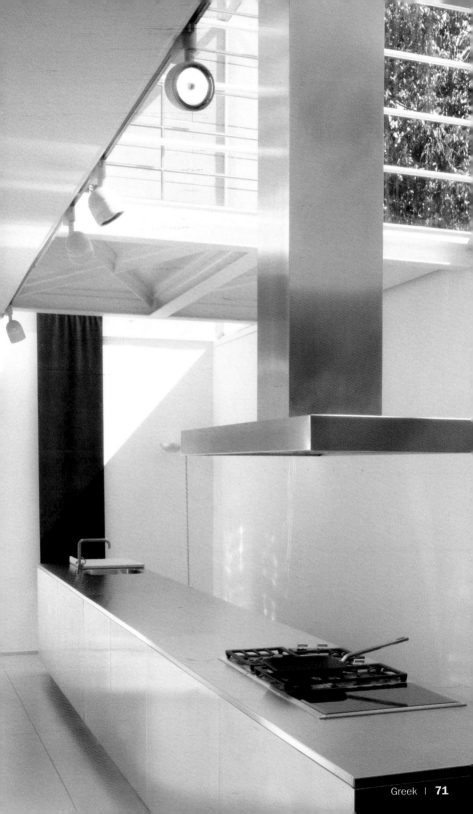

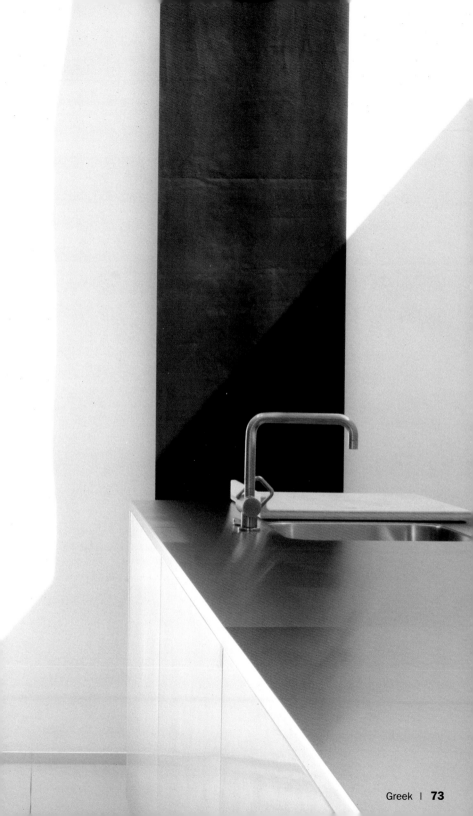

Iguapop Gallery

Design: Ernest Ameller / Grumax

Comerç 15 I 08003 Barcelona
Phone: +34 933 100 735
www.iguapop.net
Subway: Jaume I, Barceloneta
Opening hours: Mon 5 pm to 9 pm, Tue–Fri 11 am to 2:30 pm and 5 pm to 9 pm
Products: Works of art, clothes, books, magazines
Special features: Art gallery and multiproduct shop

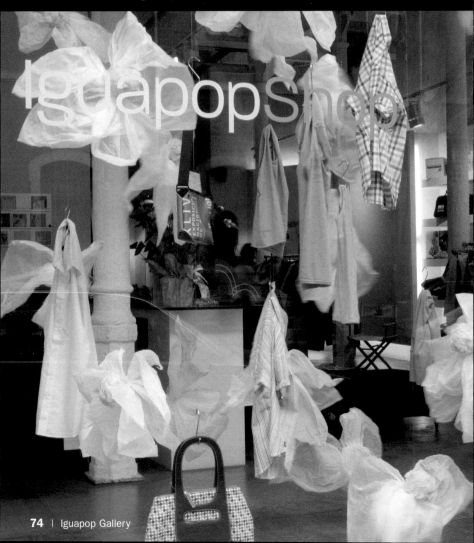

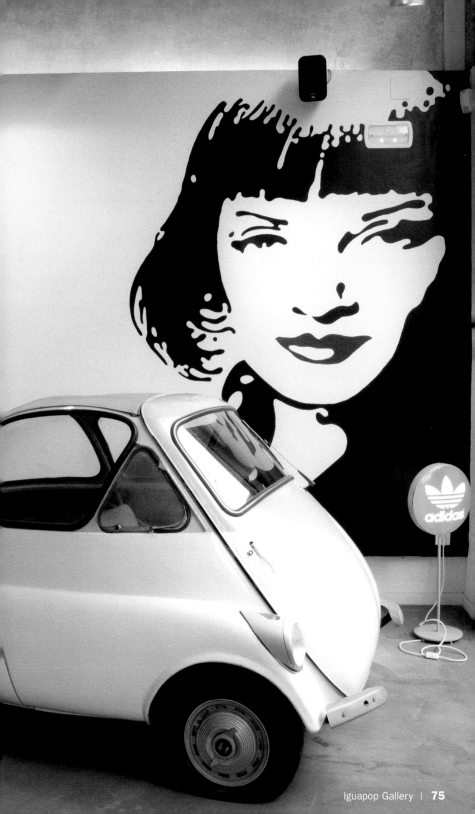

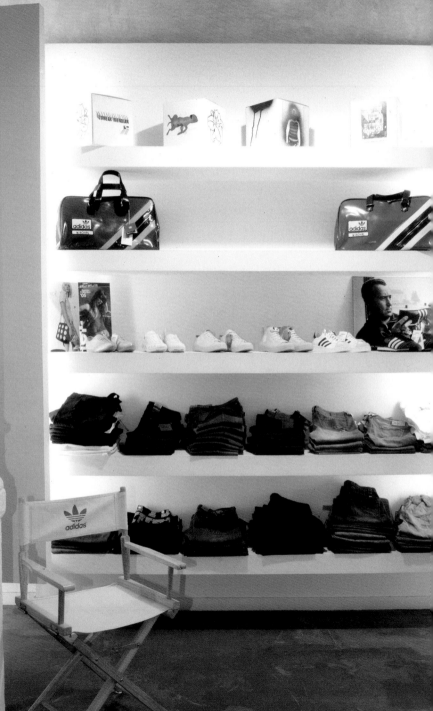

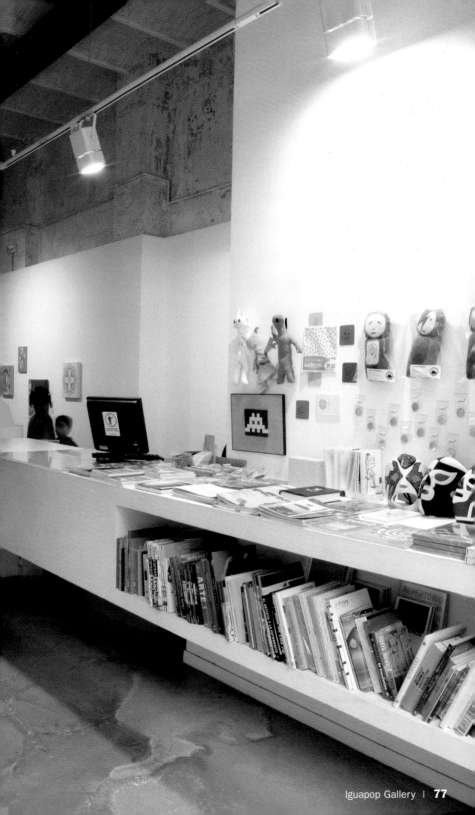

Julie Sohn

Design: Conrado Carrasco, Carlos Tejada, Estudio CCT Arquitectos

Diputació 299 I 08007 Barcelona
Phone: +34 934 875 796
Subway: Passeig de Gràcia
Opening hours: Mon–Sat 11 am to 8:30 pm
Products: Women's clothes, accessories
Special features: Rehabilitated old industrial building

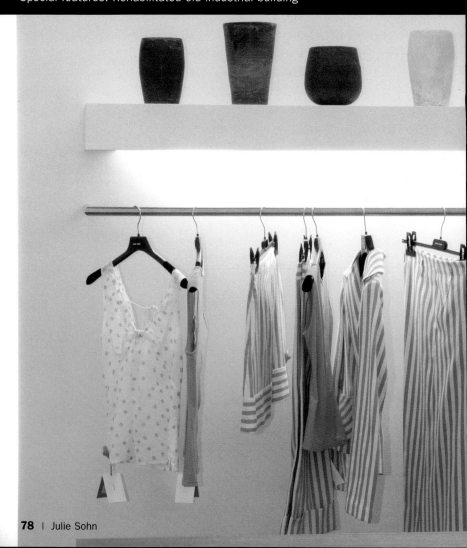

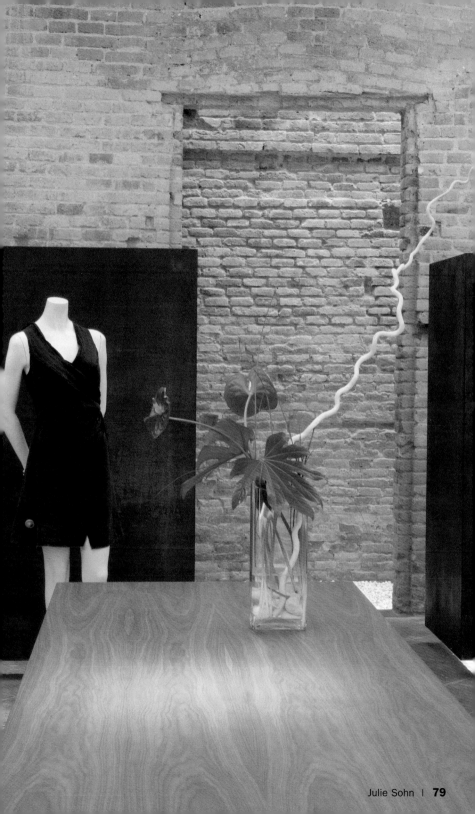

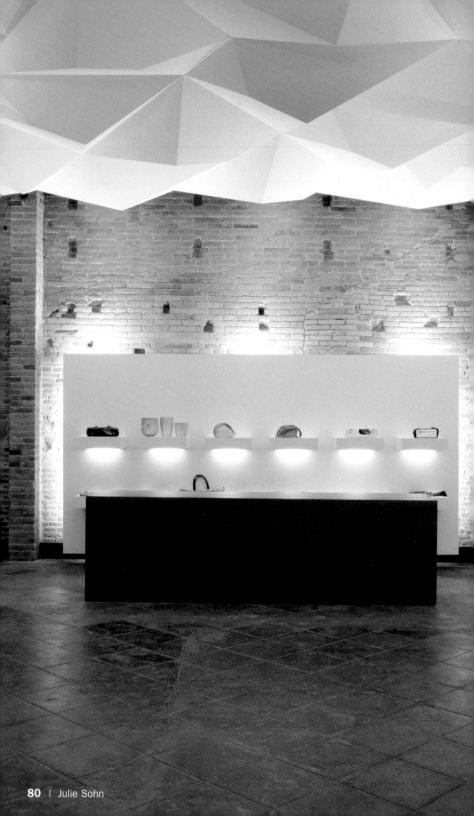

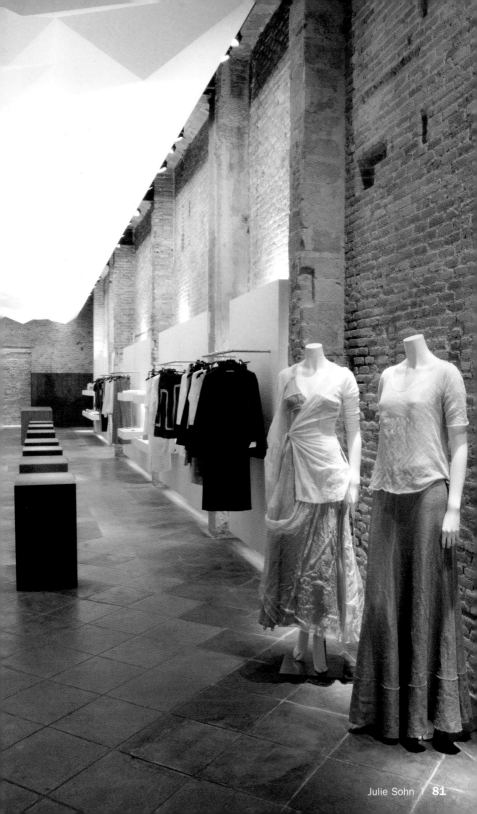

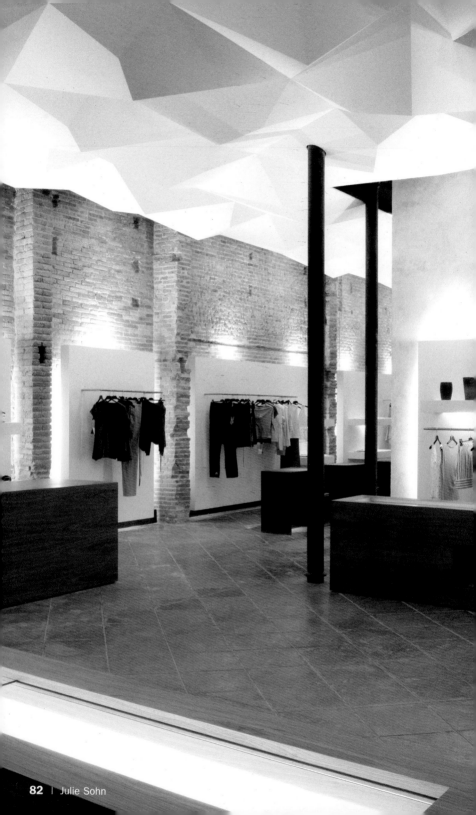

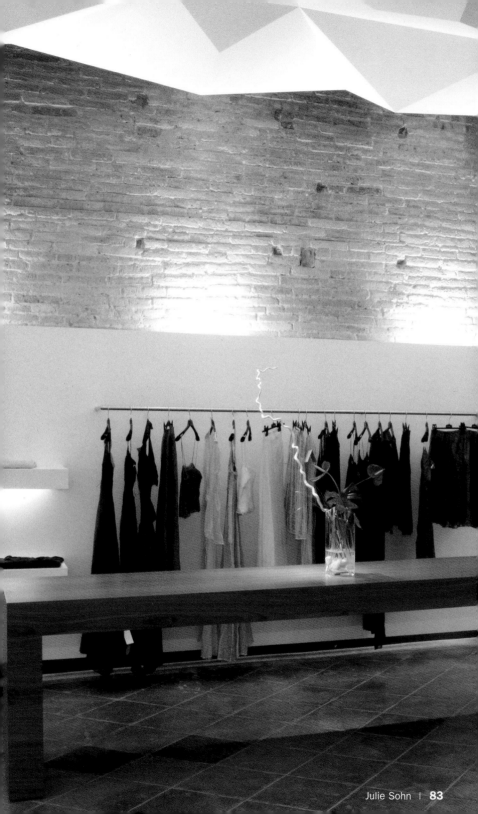

La Carte des Vins

Design: Daniel Nassar (architecture), Laurent Godel (interiors)

Sombrerers 1 | 08003 Barcelona
Phone: +34 932 687 043
www.lacartedesvins.com
Subway: Jaume I
Opening hours: Mon–Sat 10:30 am to 9:30 pm
Products: Wines, accessories, books
Special features: Large list of national and international wines

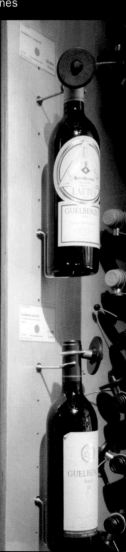

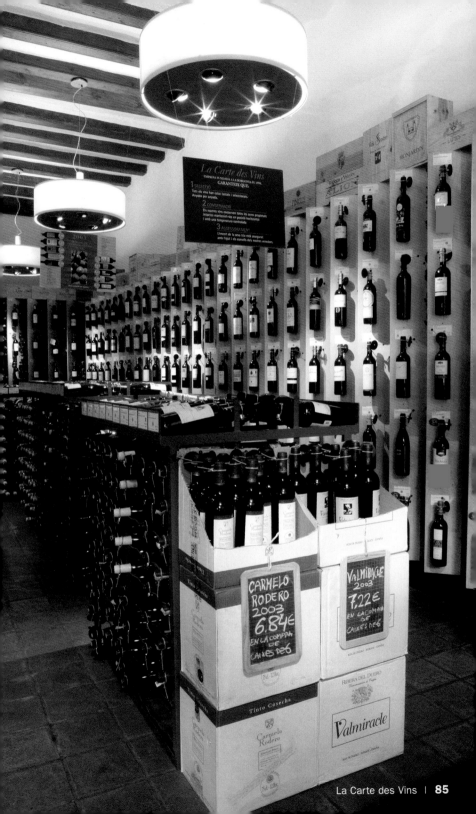

Le Boudoir

Design: Mónica Sans, Julie Plottier, Paul Reynolds

Canuda 21 | 08002 Barcelona
Phone: +34 933 025 281
www.leboudoir.net
Subway: Catalunya
Opening hours: Mon–Sat 10 am to 8:30 pm
Products: Women's lingerie, erotic cosmetics, erotic toys and books
Special features: Sexy and intimate design, combining modern lines with antiques

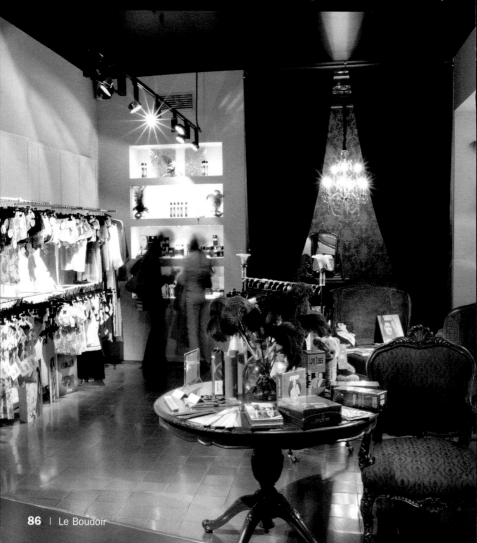

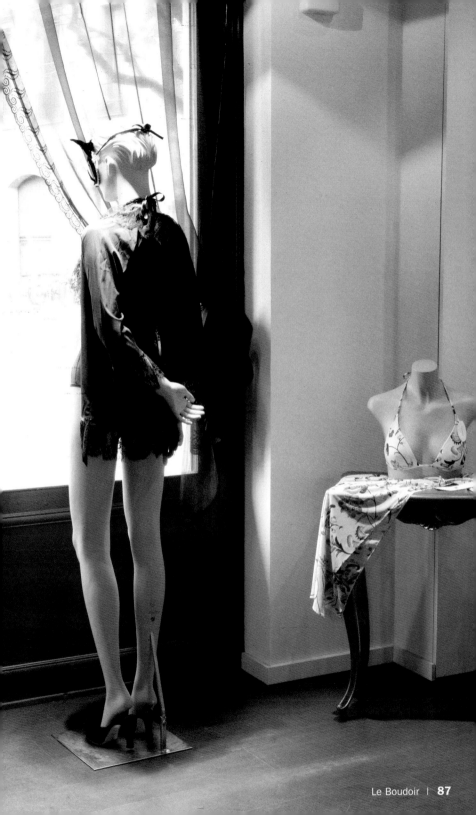

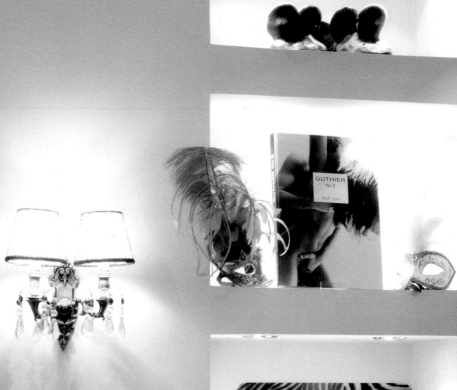

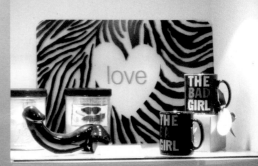

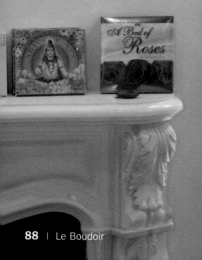

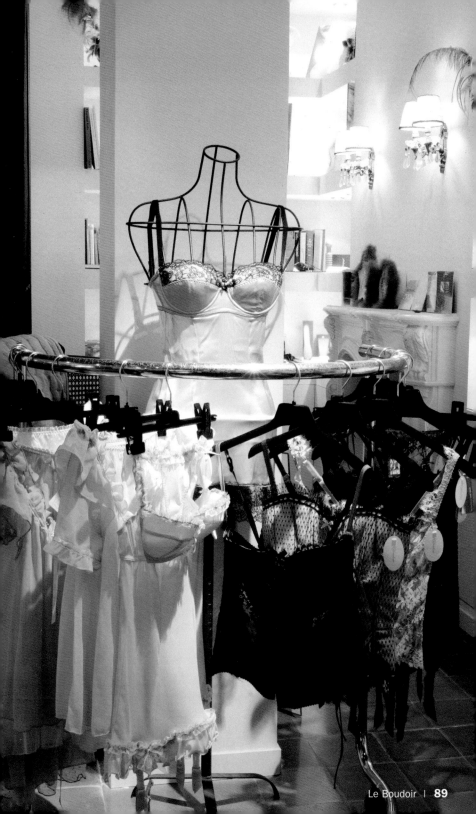

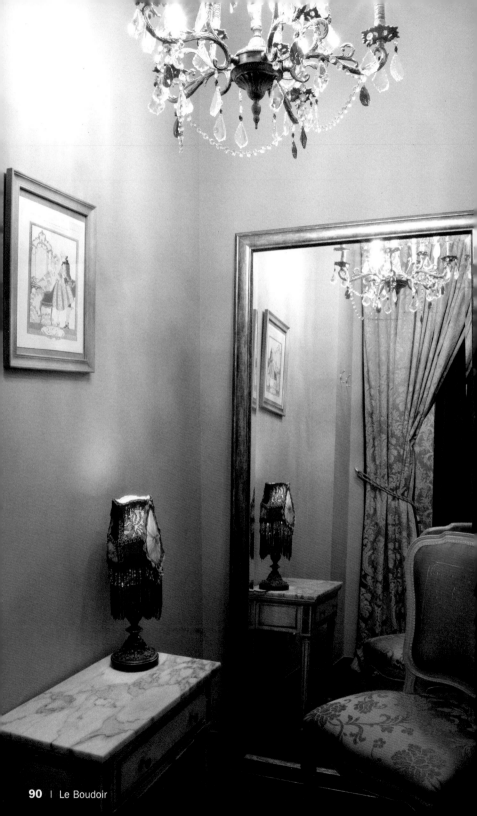

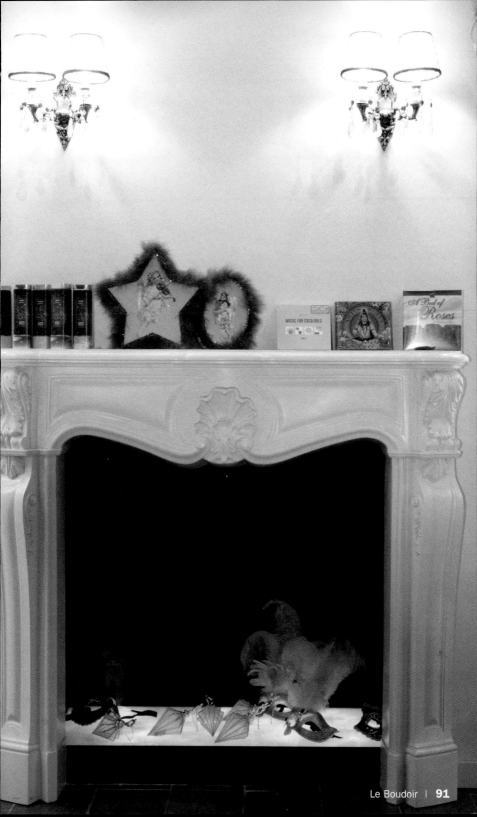

Minim

Design: Agnés Blanch, Elina Vila

Av. Diagonal 369 | 08037 Barcelona
Phone: +34 932 722 425
www.minim.es
Subway: Diagonal
Opening hours: Mon–Fri 10 am to 8 pm, Sat 10 am to 2 pm
Products: Contemporary furniture and lighting
Special features: Modern and versatile space, also offers interior design projects

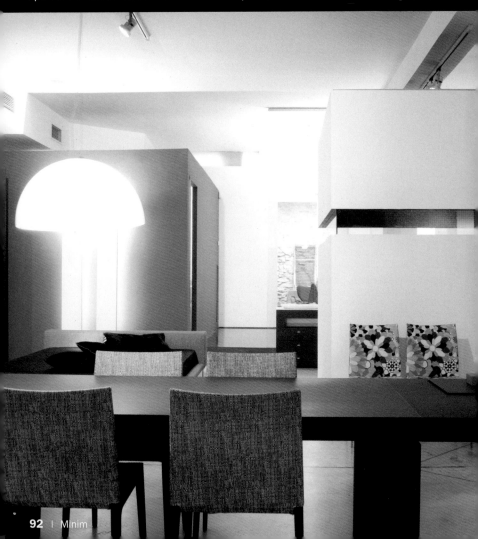

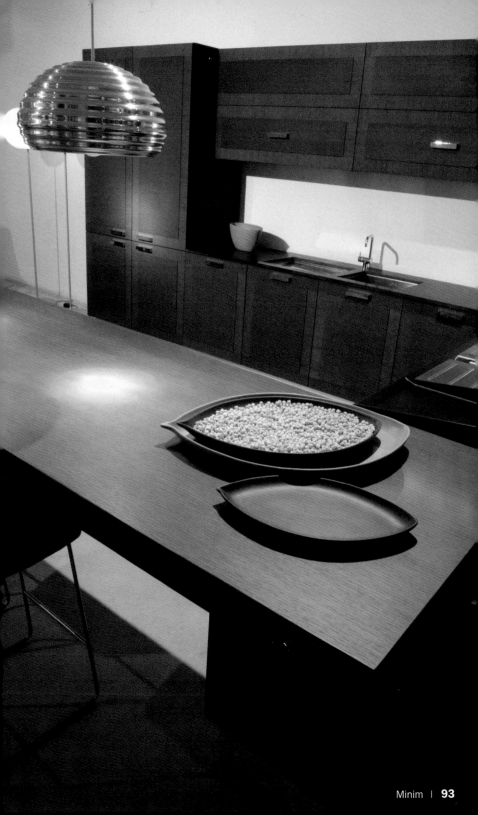

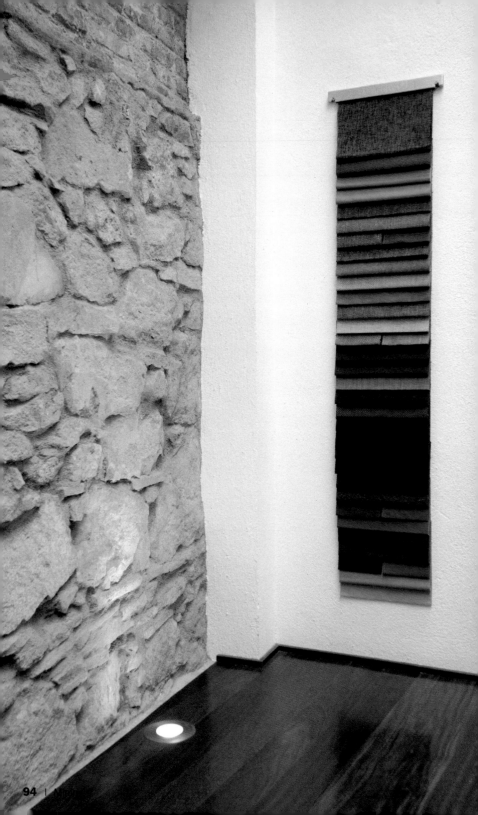

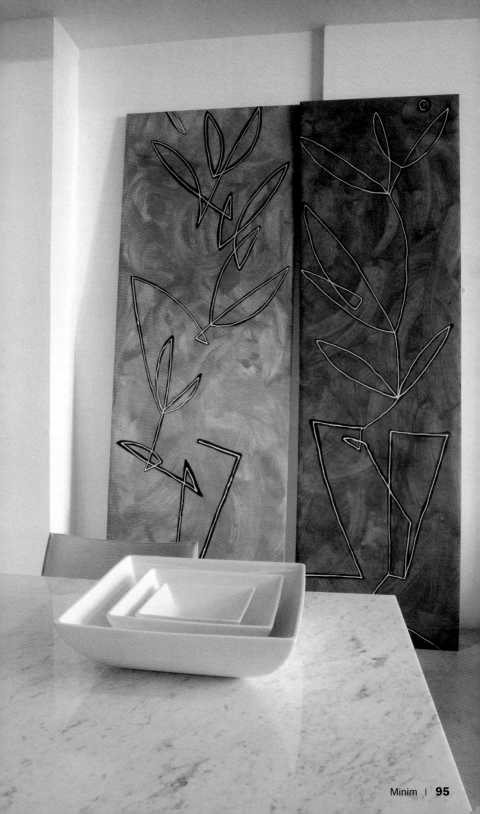

Miró Jeans

Design: Eduardo Rocamora

València 272 I 08013 Barcelona
Phone: +34 932 722 491
www.antoniomiro.es
Subway: Passeig de Gràcia
Opening hours: Mon–Sat 10:30 am to 9 pm
Products: Street casual wear
Special features: Eclectic design for eclectic clothes

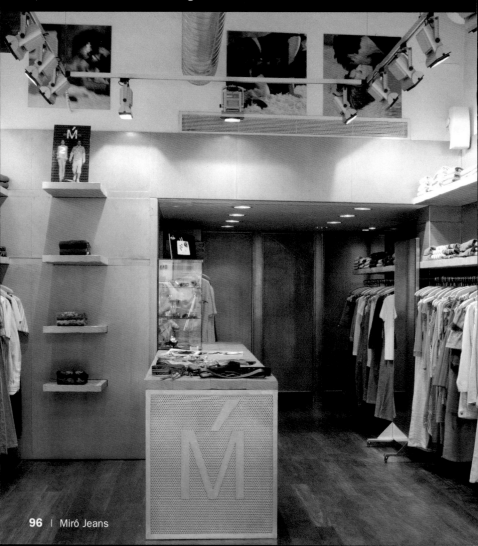

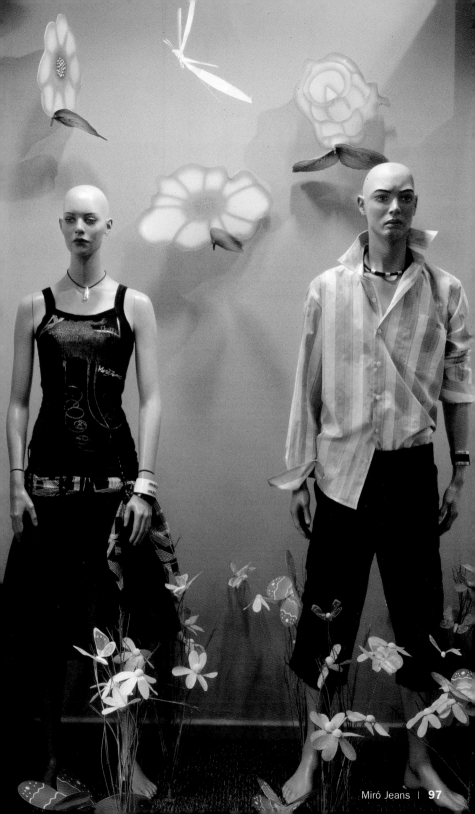

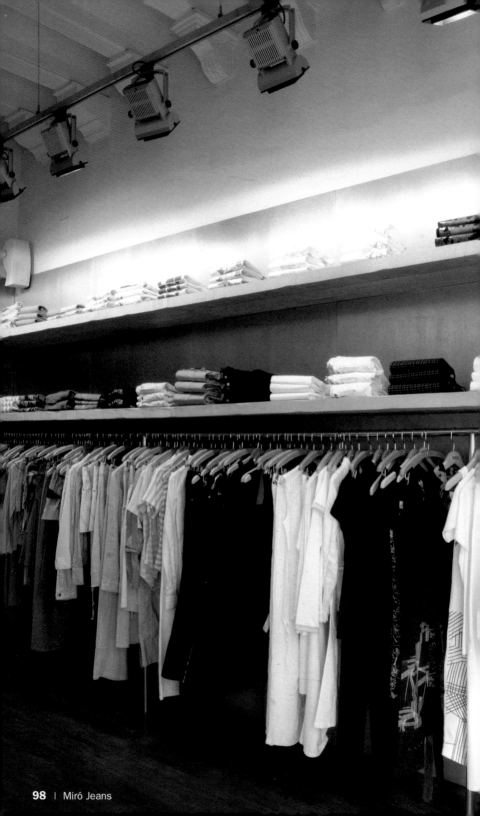

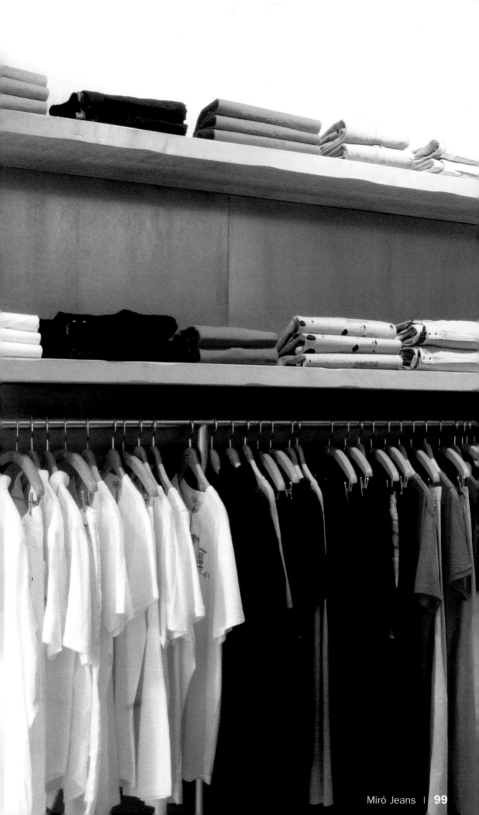

Miss Sixty/Energy

Design: Estudio 63

Passeig de Gràcia 3 / 08007 Barcelona
Phone: +34 933 425 502
www.misssixty.com
Subway: Catalunya
Opening hours: Mon–Sat 10 am to 9 pm
Products: Men's and women's casual street wear
Special features: Colorful interior design concept combined with peculiar furniture

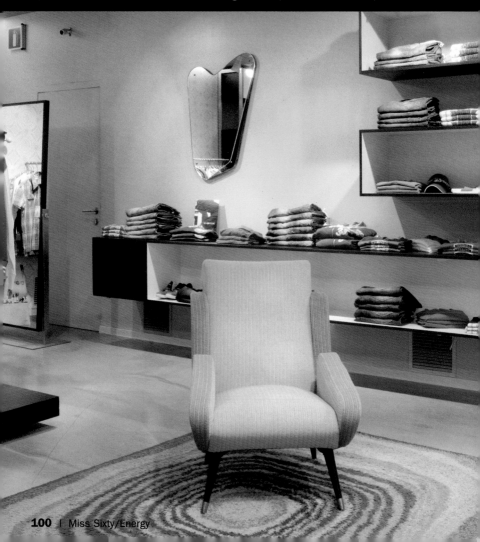

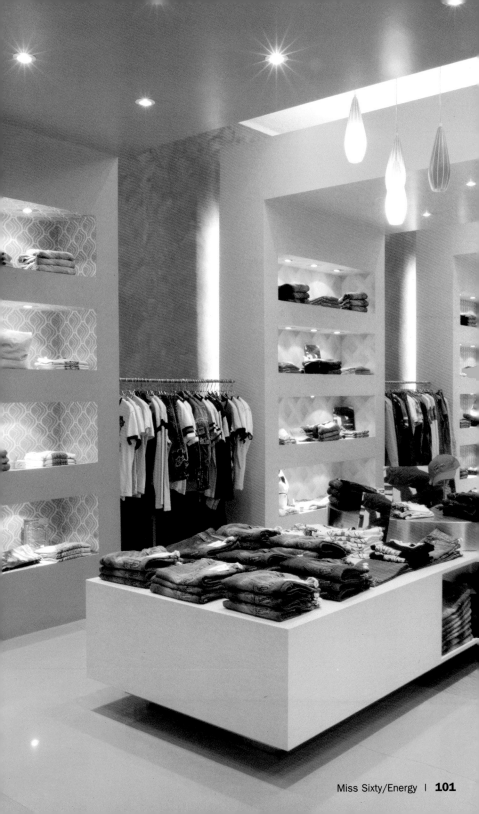

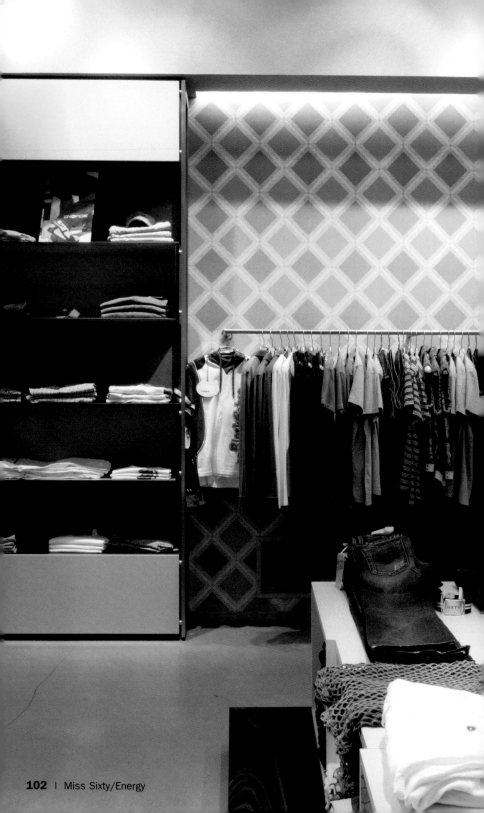

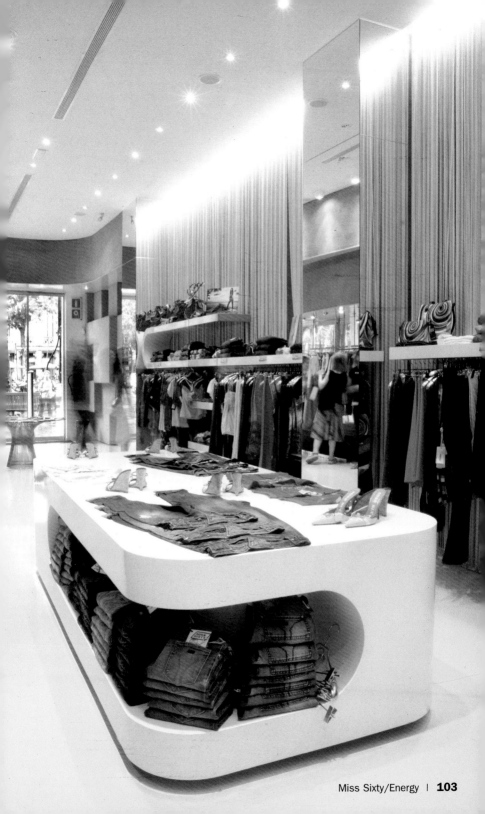

Papabubble

Design: Mr.Bones

Ample 28 | 08002 Barcelona
Phone: +34 932 688 625
www.papabubble.com
Subway: Drassanes, Jaume I
Opening hours: Tue–Fri 10 am to 2 pm and 4 pm to 8:30 pm, Sat 10 am to 8:30 pm,
Sun 11 am to 7:30 pm
Products: Sweets
Special features: Home made sweets, the process can be followed by the customers

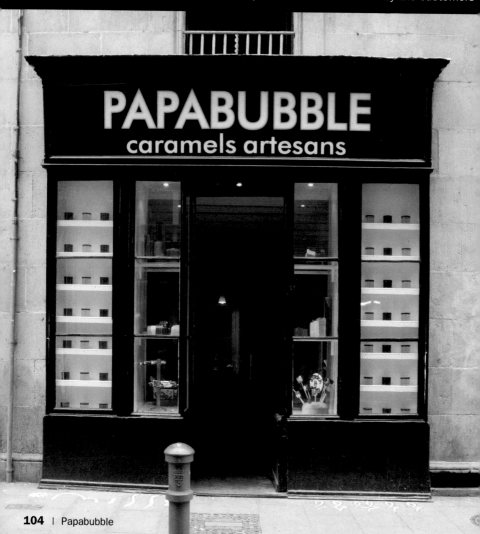

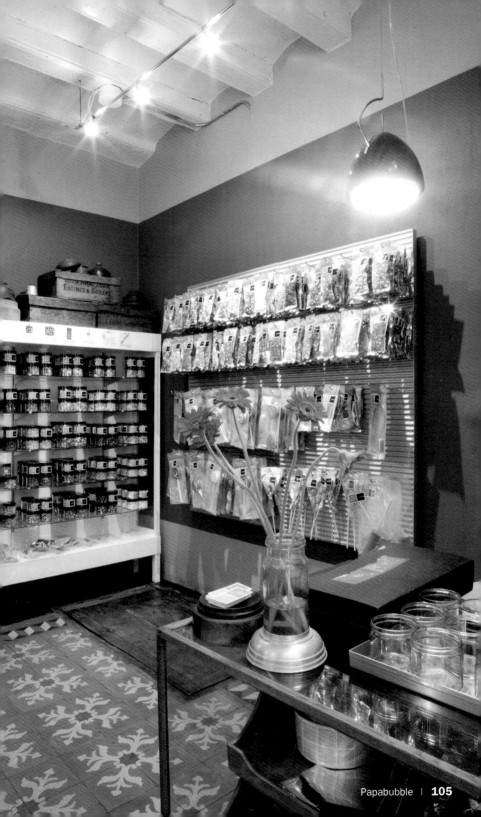

Santa Amèlia 37 | 08034 Barcelona
Phone: +34 932 060 099
www.pilma.com
Subway: Maria Cristina
Opening hours: Mon–Sat 10 am to 2 pm and 4:30 pm to 8:30 pm
Products: Contemporary furniture, lighting, kitchen and bathroom fixtures
Special features: Two other stores in Barcelona

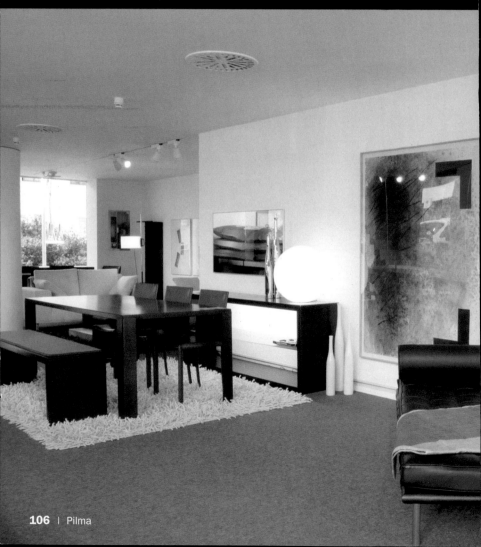

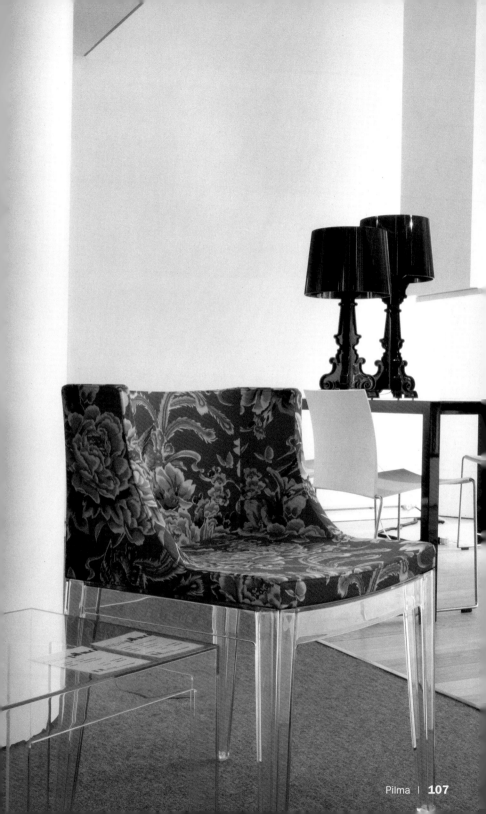

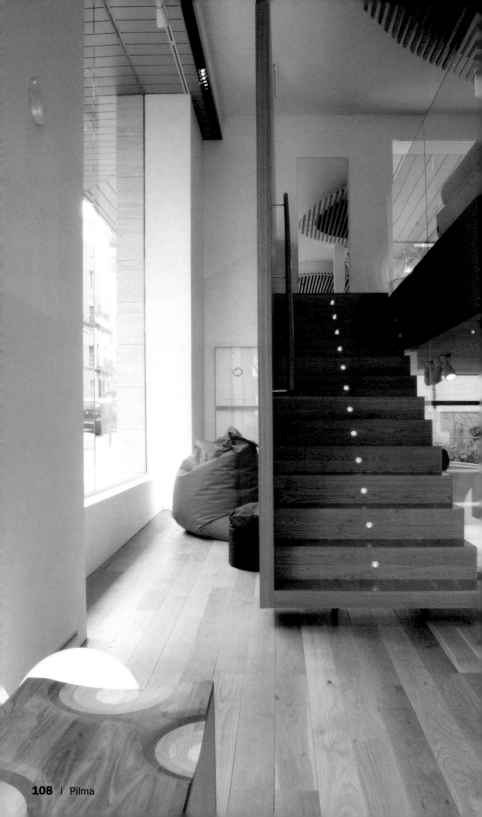

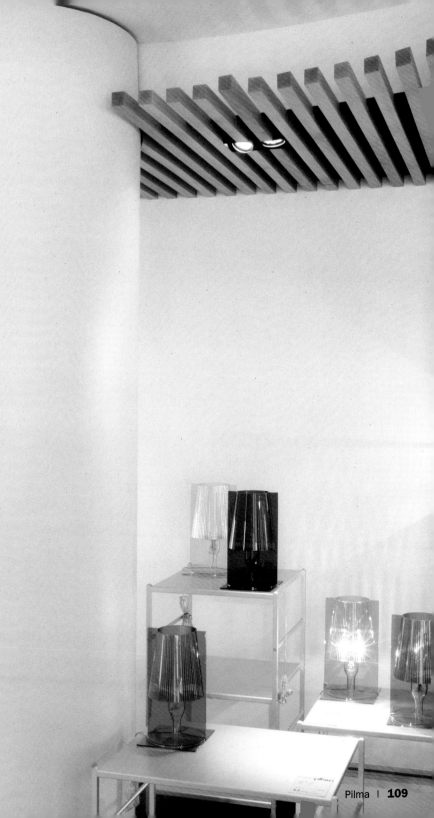

Doctor Dou 10 | 08001 Barcelona
Phone: +34 934 127 199
www.actar.es/ras.html
Subway: Catalunya, Liceu
Opening hours: Tue–Sat 11 am to 9 pm
Products: Books and magazines specialised in architecture, art, design and
photography, objects
Special features: Holds art and architecture exhibitions and lectures

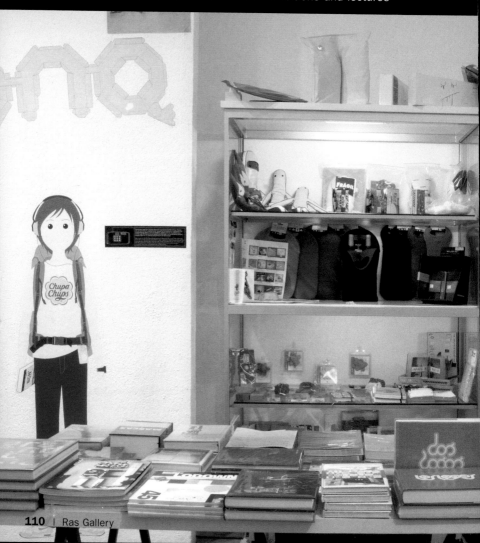

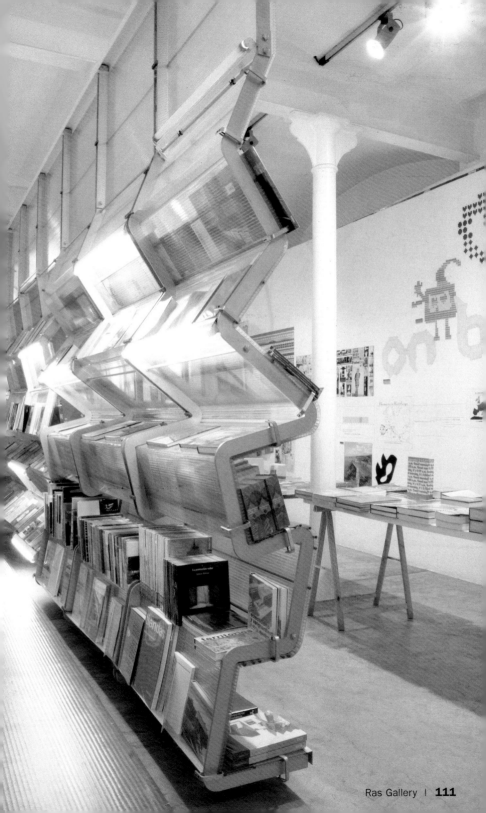

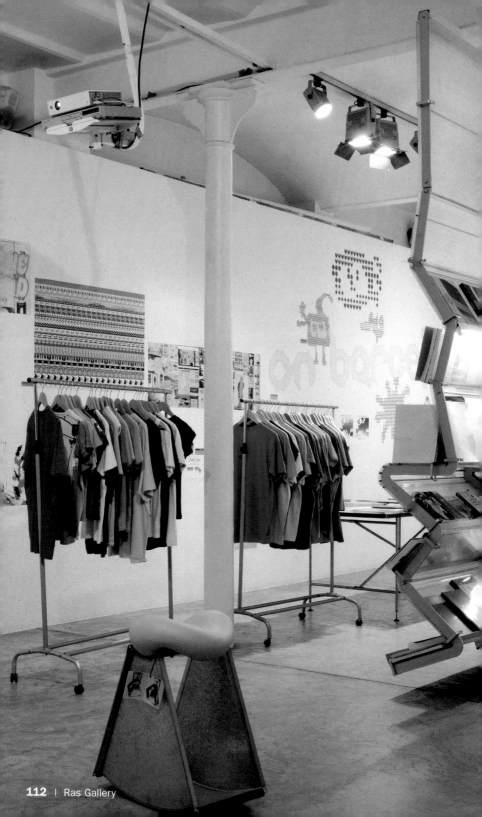

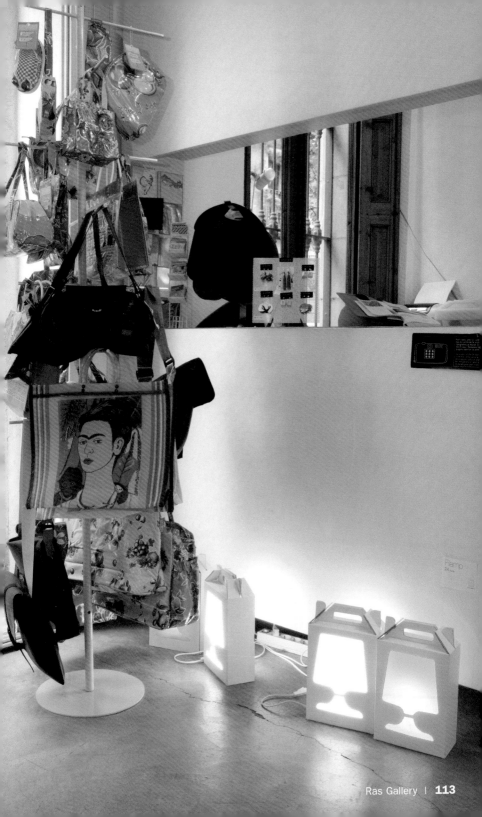

Av. Diagonal 409 I 08008 Barcelona
Phone: +34 934 873 333
www.rosaclara.es
Subway: Diagonal
Opening hours: Mon-Sat 10 am to 8:30 pm
Products: Wedding dresses, own collection and especially commissioned collections
Special features: Personalized and custom-made dresses

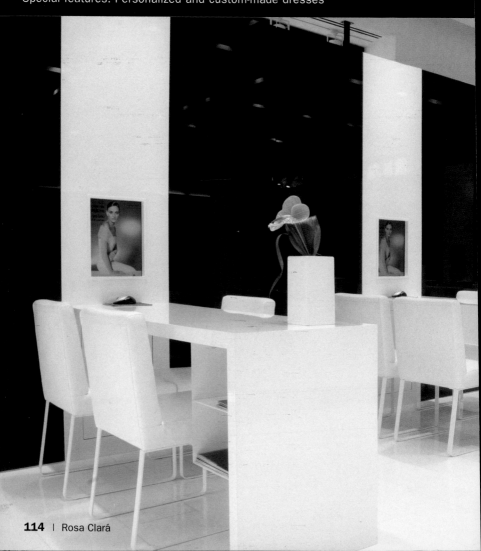

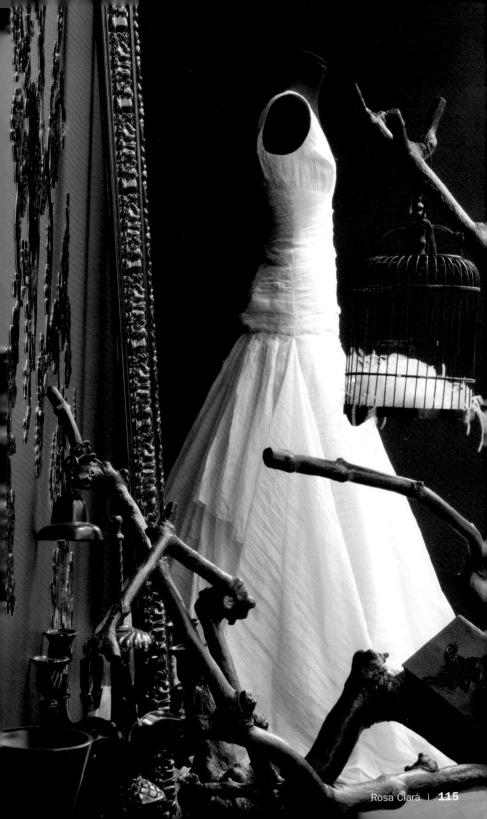

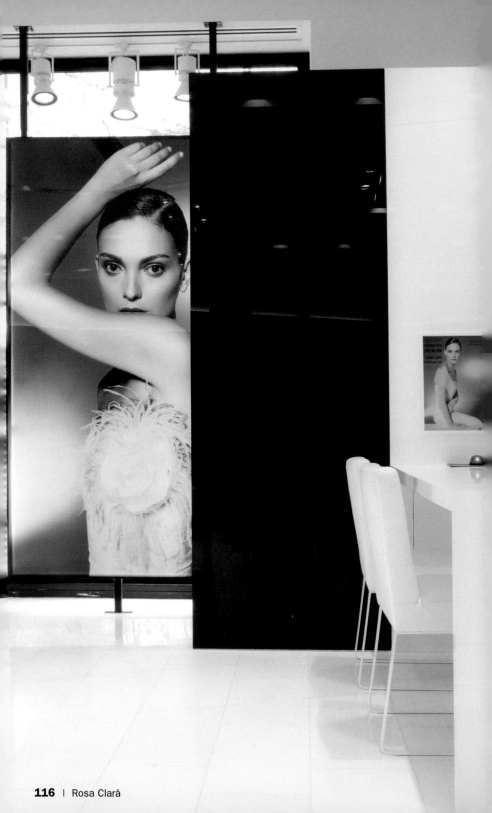

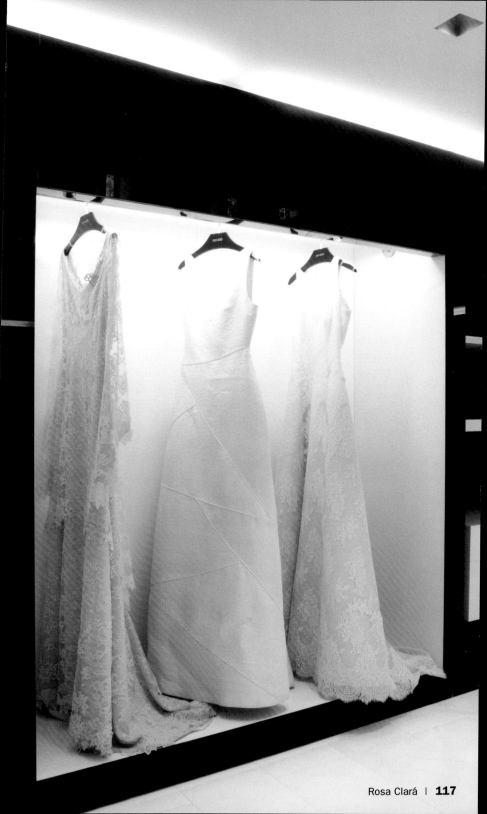

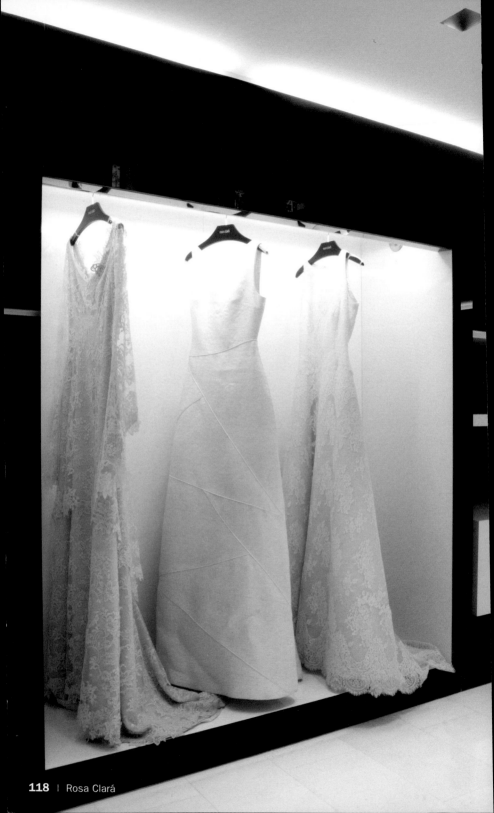

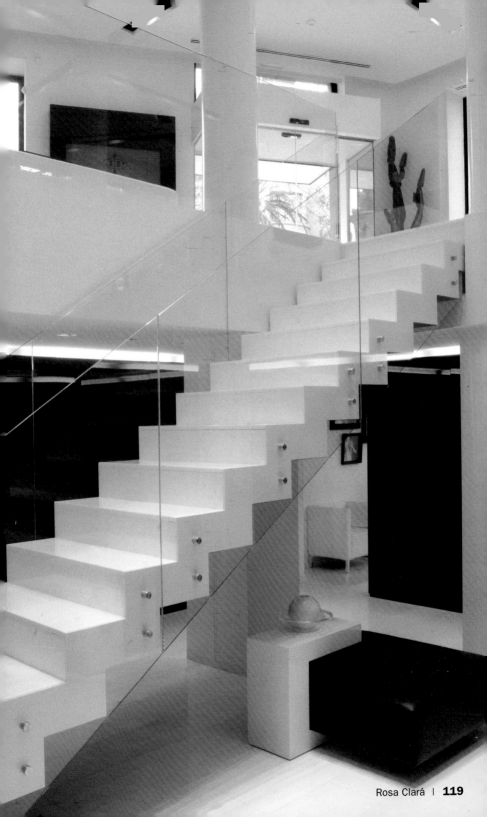

Sita Murt

Design: Manel Bailo

Avinyó 18 | 08002 Barcelona
Phone: +34 933 010 006
www.sitamurt.com
Subway: Catalunya, Liceu
Opening hours: Mon–Sat 10:30 am to 8:30 pm
Products: Women's clothes
Special features: Designers such as Sita Murt, Paul & Joe, Anna Pianura, Essenciel, Antik Batik, Rutzü, Replay, Joe's and Julie Sohn

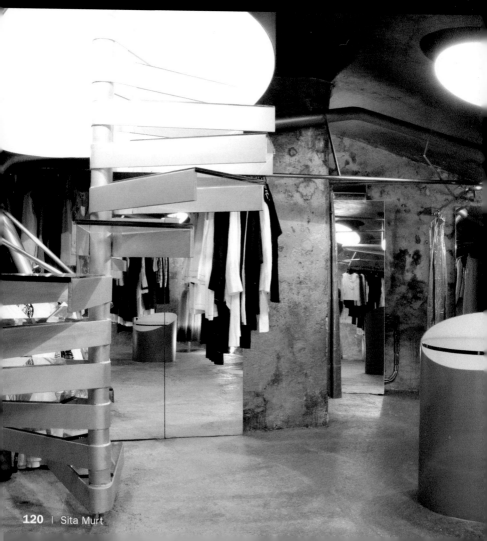

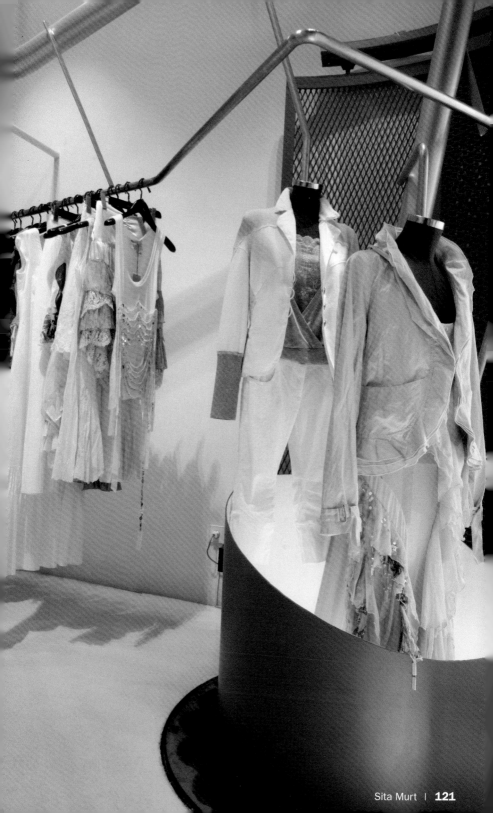

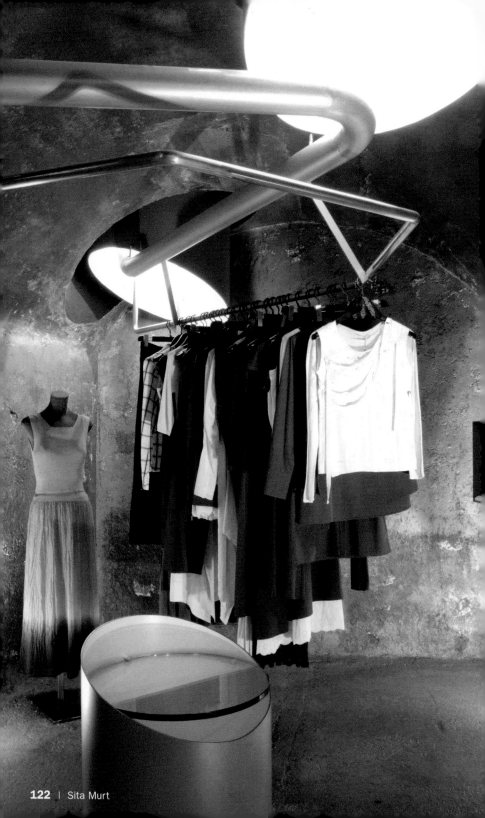

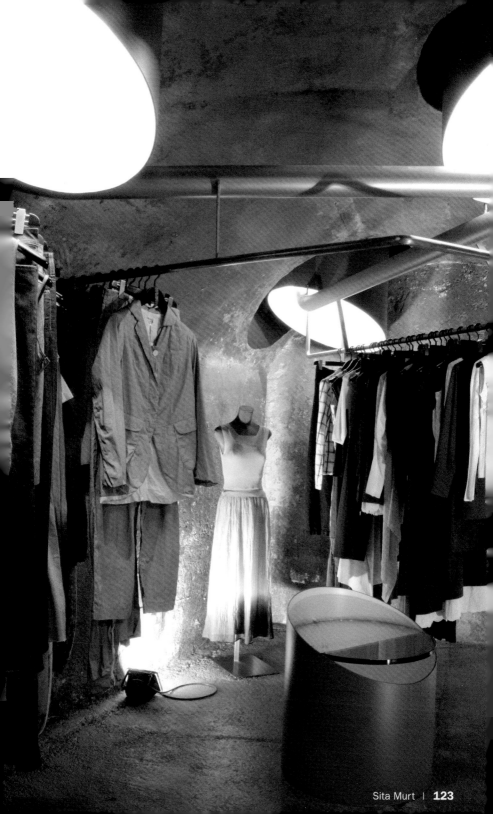

Vinçon

Design: Fernando Amat

Passeig de Gràcia 96 | 08008 Barcelona
Phone: +34 932 156 050
www.vincon.com
Subway: Diagonal
Opening hours: Mon–Sat 10 am to 8:30 pm
Products: More than 10,000 products for the home and the office, gifts
Special features: Offers a wide range of objects in a flexible and changing setting,
also houses art exhibitions

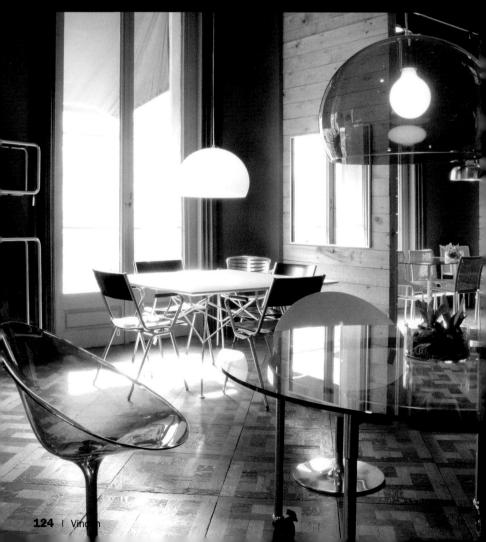

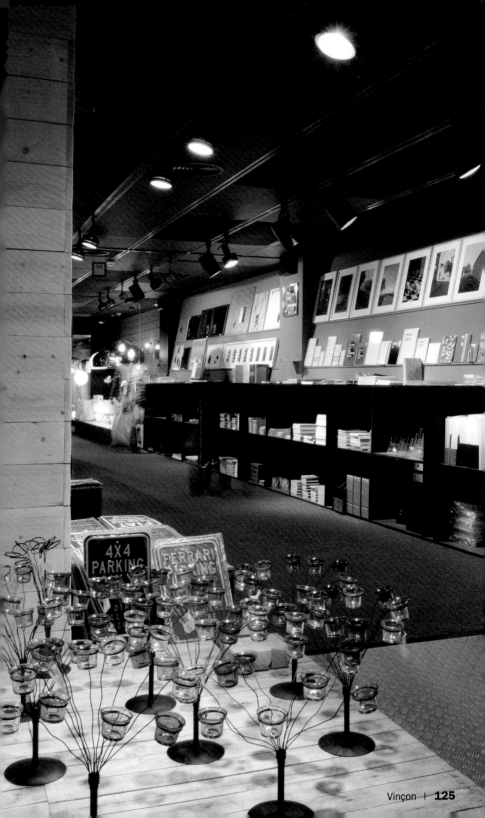

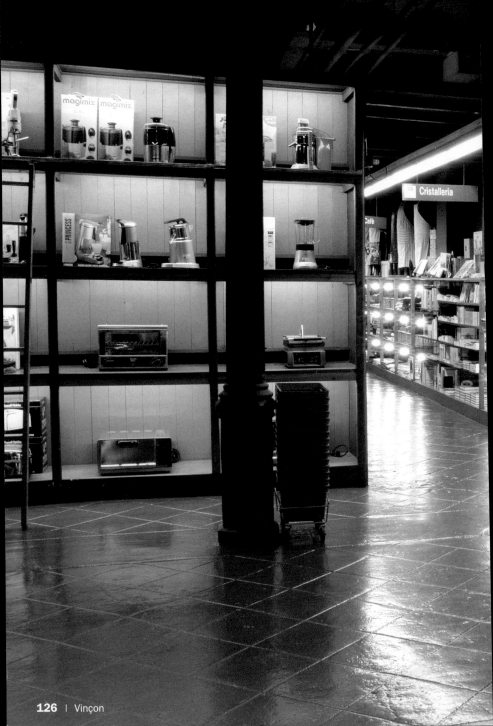

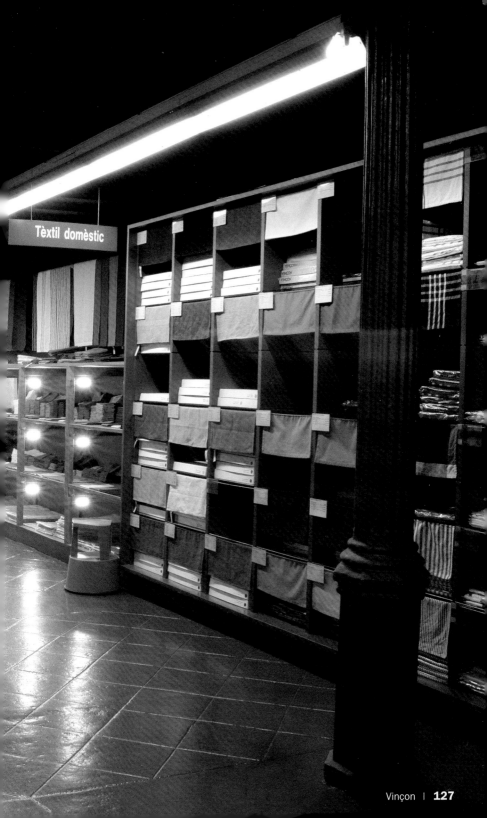

Tèxtil domèstic

Vitra

Design: Sevil Peach

Plaza Comercial 5 I 08003 Barcelona
Phone: +34 932 687 219
www.vitra.com
Subway: Jaume I
Opening hours: Mon–Sat 10:30 am to 2 pm and 5 pm to 8 pm
Products: Home and office furniture
Special features: Contemporary and classic designs

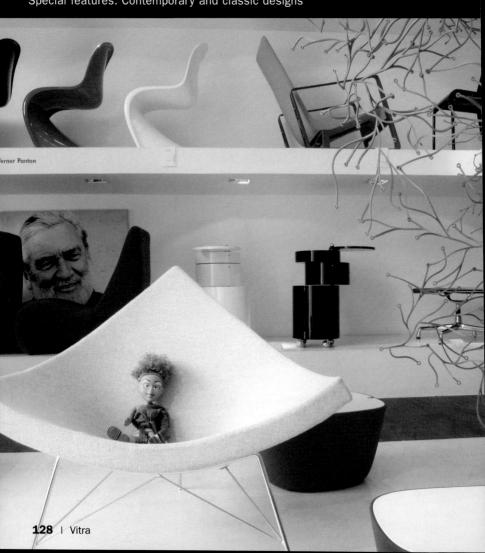

Werner Panton

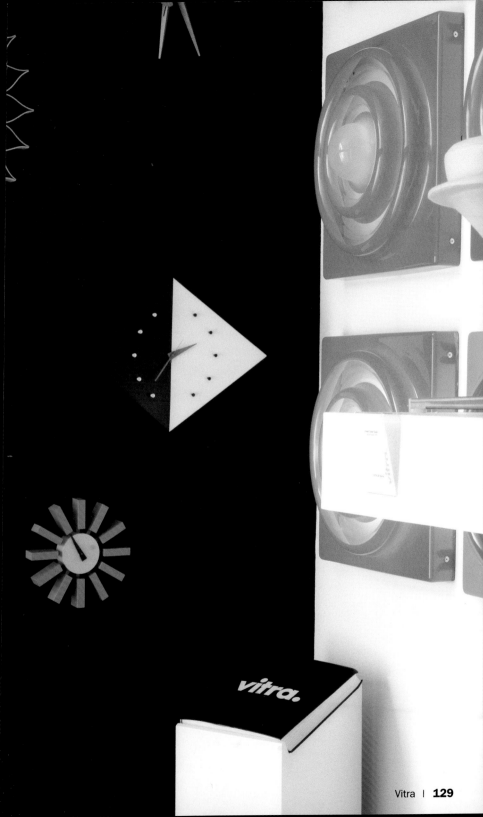

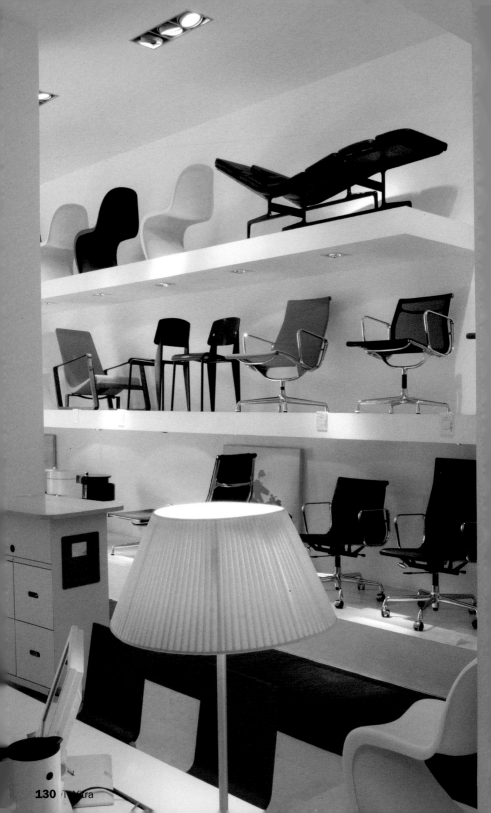

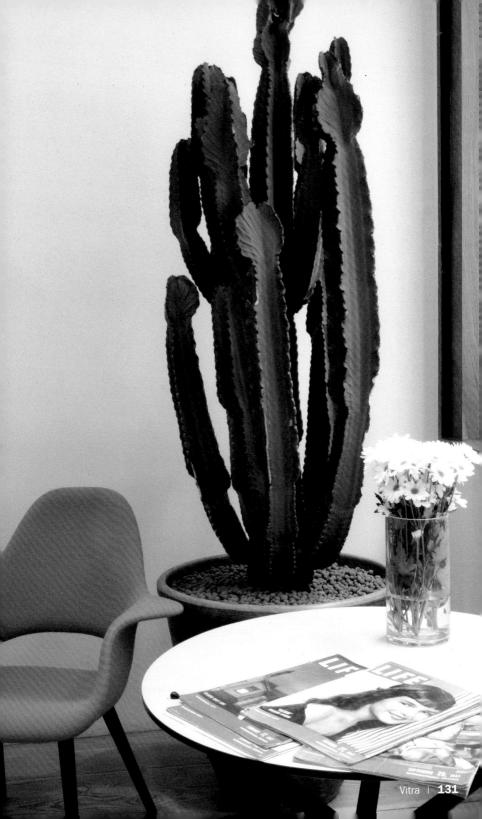

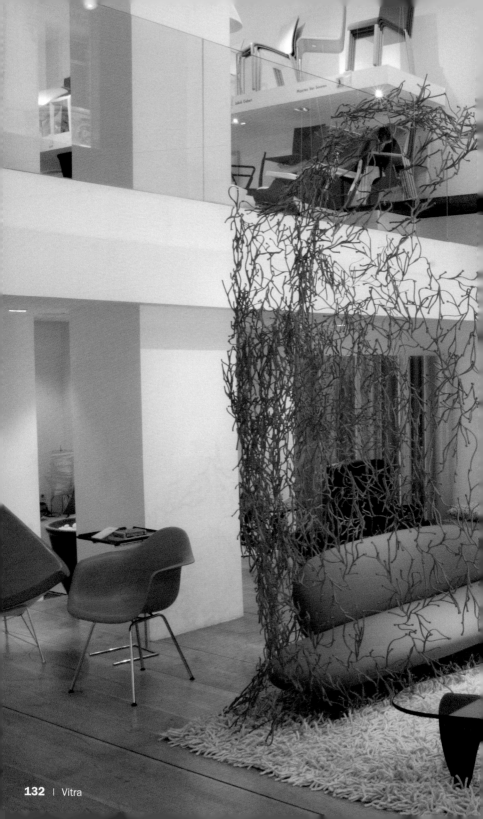

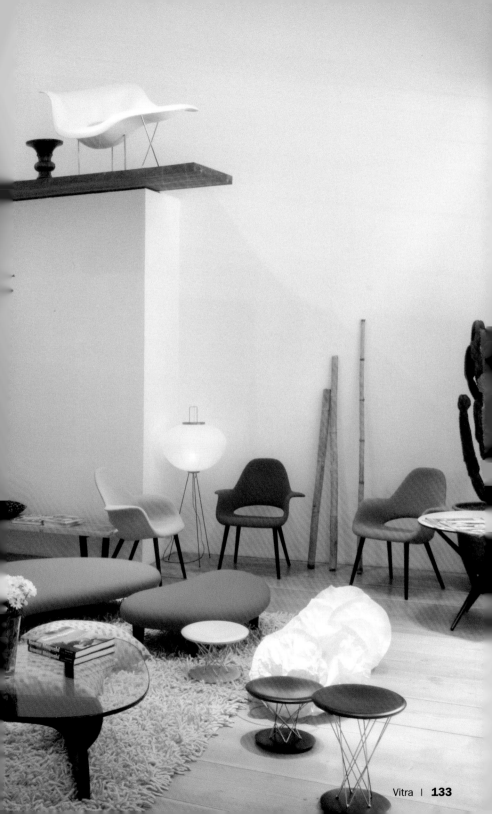

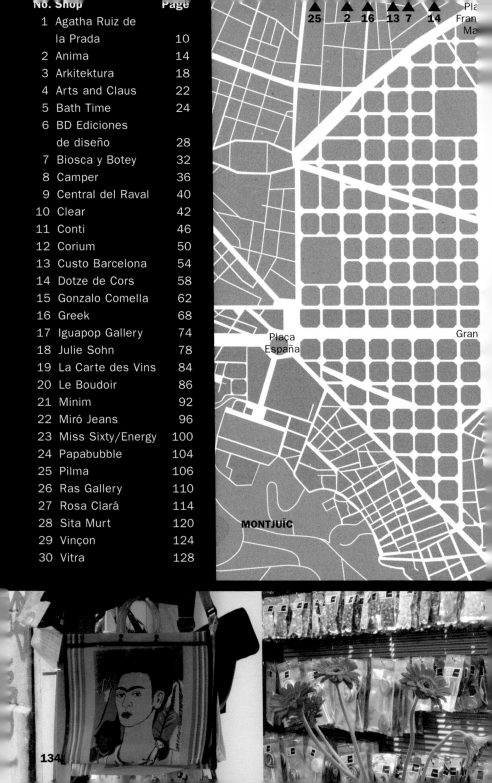

25 2 16 13 7 14 Pla Fran Ma

Plaça España

Gran

MONTJUÏC

134

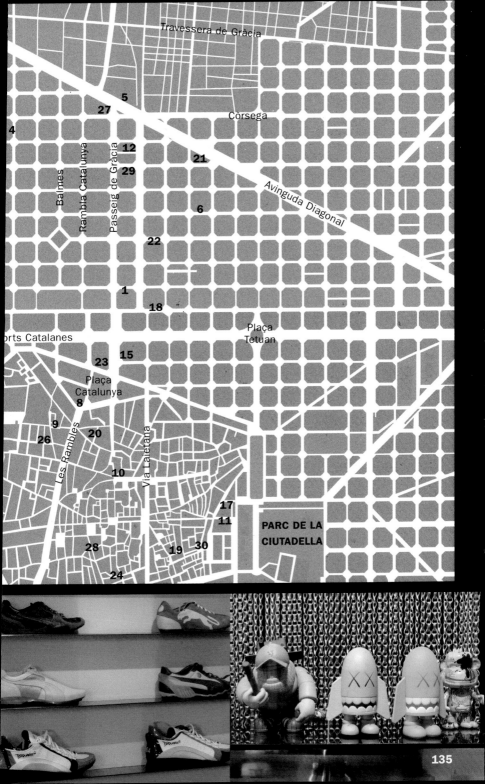

Travessera de Gràcia

Còrsega

Avinguda Diagonal

Balmes

Rambla Catalunya

Passeig de Gràcia

Corts Catalanes

Plaça
Tetuan

Plaça
Catalunya

Les Rambles

Via Laietana

PARC DE LA
CIUTADELLA

5
27
4
12
21
29
6
22
1
18
23
15
8
9
26
20
10
17
11
28
19
30
24

COOL SHOPS

Size: 14 x 21.5 cm / 5½ x 8½ in.
136 pp
Flexicover
c. 130 color photographs
Text in English, German, French,
Spanish and Italian

Other titles in the same series:

ISBN
3-8327-9070-5

ISBN
3-8327-9038-1

ISBN
3-8327-9071-3

ISBN
3-8327-9022-5

ISBN
3-8327-9072-1

ISBN
3-8327-9021-7

ISBN
3-8327-9037-3

**To be published in the
same series:**

Amsterdam
Dubai
Hamburg
Hong Kong
Madrid
Miami

San Francisco
Shanghai
Singapore
Tokyo
Vienna

teNeues